REMEMBERING

LUBEC

REMEMBERING
LUBEC

Stories from the Easternmost Point

RONALD PESHA

FOREWORD BY JUDITH P. SULZBERGER, MD,
RETIRED DIRECTOR OF THE *NEW YORK TIMES*

Charleston London

THE
History
PRESS

Published by The History Press
Charleston, SC 29403
www.historypress.net

Copyright © 2009 by Ronald Pesha
All rights reserved

First published 2009

Manufactured in the United States

ISBN 978.1.59629.625.1

Library of Congress Cataloging-in-Publication Data

Pesha, Ronald.
Remembering Lubec : stories from the easternmost point / Ronald Pesha ; foreword by
Judith P. Sulzberger.
p. cm.
Includes bibliographical references.
ISBN 978-1-59629-625-1
1. Lubec, Me.--History. 2. Lubec, Me.--Biography. I. Title.
F29.L9P47 2009
974.1'42--dc22
2009025558

To my wife Ronna and son Noah.

CONTENTS

FOREWORD

Lubec is a beautiful, remote, "down east" town on the coast of Maine. Not many people, outside of Mainers, know of its existence, which is why I bought a house there fifteen years ago, Now, I am happy to say, we have a book about Lubec. Ron Pesha has written a well-researched and well-illustrated account of the town from its early nineteenth-century origins. What follows is a story full of historical facts and family anecdotes. It will introduce Lubec to the rest of the country.

Judith P. Sulzberger, MD
retired director of the *New York Times*

ACKNOWLEDGEMENTS

It is presumptuous for a person from away to write about Lubec's history. I merely researched and recorded. Native Lubeckers read the chapters for accuracy.

THE EASTERNMOST POINT

The easternmost point! Where the sun rises first! Sunrise County, U.S.A., the descriptive sobriquet proudly espoused by Washington County, Maine.

Human beings enjoy extremes. The highest and lowest, largest and smallest, hottest and coldest—and the most easterly. It is remote to reach but is still a popular draw, hosting guests from the nation and the world.

Millions travel to Key West, Florida, to stand at the southernmost point of the forty-eight contiguous states. Northwest Angle, Minnesota, lies off the proverbial beaten path but remains accessible by road. Westernmost Point Alava in Washington State requires a three-mile hike. A long but easy drive achieves the easternmost terminus, where America begins.

Sail Rock lies a few hundred yards off the mainland of Maine at West Quoddy Head in Lubec. The geological coordinate of sixty-six degrees, fifty-seven minutes, two seconds west longitude clearly defines its status. Its dark basaltic ledge still looms—early sailors perceived it as a black omen in an era preceding aids to navigation. Fortunately, a lighthouse and various contrived fog signals came into operation one hundred years before the century-old postcard shown here had converted peril into a tourist spectacle.

Extreme tides, about twenty-two feet at Sail Rock and increasing farther north, compound the danger. West Quoddy Head lies in the Bay of Fundy, named by sixteenth-century Portuguese as "Rio Fundo" or "deep river." A rift caused in ancient times when Nova Scotia split off the mainland created a steadily narrowing arm of water. This funnel forces tidewaters higher. The time required for the wave to move up from the mouth and back, about twelve hours and twenty-five minutes, equals the time from one high tide to the next, amplifying through resonance the variation between low and high. Routinely, violent waves pound Sail Rock, discouraging visits to this ultimate

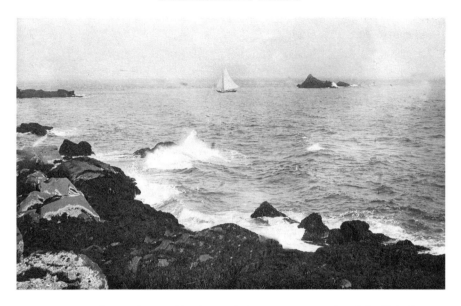

Sail Rock, lying off West Quoddy Head, literally the easternmost point of the United States. *Lubec Historical Society.*

prominence. Tourists seem satisfied to visit the lighthouse and the granite marker that lie conveniently above the shore.

Furthermore, fog often obscures Sail Rock from view. Clearly treacherous to unwary mariners, fog multiplied the risk to the sailors of old in myriad ways. The *New Bedford Mercury* reported in 1836 that a navigator often loses his way, "having no landmark by which to steer," and finds his ship not merely aground but splintered.

After construction of the lighthouse, sailors became accustomed to firing a gun in the soup, triggering a response from the weary arm of the light keeper, who rang the fog bell by hammer until he could assume that the ship had made passage beyond danger. Peter Godfrey, the keeper from 1813 to 1839, told Maine state geologist Dr. Charles T. Jackson that he averaged attending to bell ringing one hundred days a year, especially June through August.

Indeed, the summer months remain among the foggiest of the year, disheartening tourists eager to photograph the landscape, as Dr. Charles T. Jackson described in 1831: "[West Quoddy's] thick mantling fogs detract nothing from the beauty of the scene. There is serenity even in the sound of the fog bell, as its warning note echoes among the dark caverns and rocky crags, giving notice to the unwary mariner that he sails among dangers." Docents at the Lighthouse Visitor Center explain with serene composure that the light station exists because of the guaranteed fog.

Originally rung by hand, inventors devised clockwork apparatus to ring bells at regular intervals. The keepers found the work of cranking up heavy weights equally effortful, and the resultant bell tone mingled with surf and wind and came out the loser. Others suggested whistles powered by large bellows or horsepower (with real horses), or a steam whistle. The 1830s witnessed the Industrial Revolution in full growth, rapidly supplementing and even replacing water-powered mills with steam machinery. Steam powered the nineteenth century.

The *Mercury* story added that "a sharp tone bell might be placed on a tower or iron frame work, erected upon the Sail Rock itself, and the machinery kept in motion, by reciprocating rack-work moved by the rise and fall of the tide, a strong raft being moored close to it by heavy anchors and chains." Apparently never tried, easternmost Sail Rock today bears no incursion of human ingenuity except a U.S. Geological Survey benchmark.

West Quoddy Head and the Easternmost Point

Visitors often ask why the most easterly point bears the name *West* Quoddy Head. The international boundary line defines the easternmost designation, separating U.S. territory from Canada's Campobello Island, where East Quoddy Head lies at its northern tip. Head Harbour Lighthouse located there is also known as East Quoddy Light. It is located farther east than West Quoddy but in Canada.

To this day, tourists travel to Eastport lured by its self-descriptive name and status as "Easternmost *City* in the United States." Accurate, for Eastport is legally a city and Lubec a town. The black vertical line added to this map borders the extreme eastern edge of the city of Eastport, on Moose Island, and extends due south crossing the town of Lubec. Obviously, Lubec extends farther east, allowing Water Street businesses claim, with exactitude, easternmost deli, easternmost pub and easternmost post office, library, fish packer, hardware and more.

Farther south, note that West Quoddy Head clearly extends farther east than any of these points.

Originally part of Eastport, Lubec spun off as an independent town in 1911. This reorganization substantially reduced the square mileage of that city, also taking away the claim to easternmost point of land. The 1888 book *Eastport and Passamaquoddy* noted that

> *it used to be supposed that Todd's Head was the jumping-off place, as it was called and a good deal of sentiment has been wasted by visitors who*

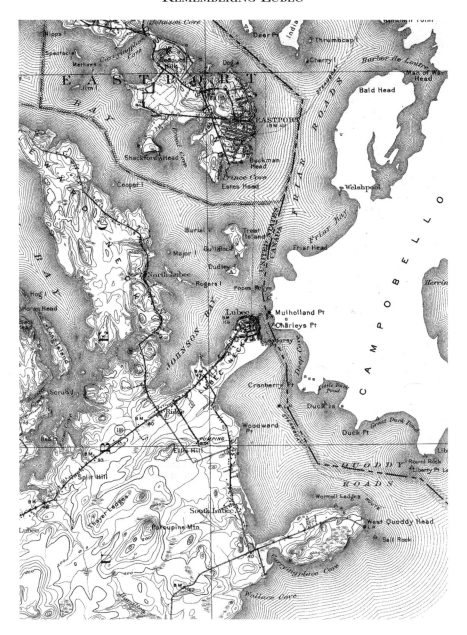

A 1908 United States Geological Survey (USGS) topographical map. *U.S. Geological Survey.*

have gone there with the supposition that they had reached the most eastern extreme of the republic, though West Quoddy Head in Lubec (its Indian name is Cheburn) is nearly a mile farther east.

Todd's Head is located a couple blocks north of Eastport's downtown off Water Street, the northern head of land where the Deer Island ferry docks in the summer. A 1949 article in the *Lubec Herald* reproduces a 1910 photograph showing then-president Howard Taft at Todd's Head. The caption noted that "metropolitan newspapers made much of the fact (?) that the President had touched the easternmost point."

Native American Place Names at West Quoddy

The earliest inhabitants frequented West Quoddy Head and certainly knew of Sail Rock as a convenient ledge for lethargic seals, which abound midsummer. According to *Indian Place-Names of the Penobscot Valley and Maine Coast*:

Wusu'-ek or Wusosis'ek (the diminutive), an old nest (Lewey Mitchell). An old word for West Quoddy Head. Wus is a nest...probably an eagle, raven, or fishhawk, all of which make bulky nests and return to the same venue many years in succession, marked the place before a lighthouse was there.

Minnicops' cook, "many rocks" (John Soctomer). Sail Rock, near West Quoddy Head. In 1770, Capt. William Owen of the Royal Navy, in his Journal, spoke of Seal Rocks instead of Sail Rock, and his plural is borne out by the Indian interpretation...it may be questioned whether considering the importance of the seal to the Indians and the certainty that this would be a location where they were found, the name was not originally Seal Rocks.

Settling the Boundary Line

Conventional assumptions suggest that the Revolutionary War settled the borders of the new nation. Was not the Paris document of 1783 a peace treaty? While the agreement between the fledgling and nervous United States and mighty Great Britain specified borders between British territory and American, much remained ambiguous. And many felt dissatisfied.

The St. Croix River defined the boundary between Maine and what is now the Canadian boundary prior to 1783. The 1919 book *Maine and the Northeastern Boundary Controversy* details subsequent events leading to the treaty.

In 1780, the British cabinet proposed land northeast of the Piscataquis River in southern Maine up to the St. Croix River as a province named "New Ireland." This territory is most of Maine. In 1782, Ben Franklin, John Jay and John Adams traveled to Paris supporting a boundary: "East, by a line to be drawn the middle of the St. Croix from its mouth in the bay of Fundy to its source, and from its source directly north to Highlands which divide the rivers that fall into the Atlantic Ocean from those which fall into the River St. Lawrence." The Treaty of Paris in 1783 closely met these demands, but subsequent trade restrictions (resulting in pervasive smuggling activities) created smoldering resentments, leading to the War of 1812.

The 1829 book *A Survey of the State of Maine* writes that early in 1814 a pamphlet appeared in London urging that Great Britain annex most of northern Maine "to sustain a claim to a different boundary from that heretofore understood, even by themselves, as established by the Treaty of 1783." However, lacking any decisive actions, the resulting stalemate led the United States and Britain to sign the Treaty of Ghent in December 1814. Nevertheless, British occupied Eastport from July 1814 to June 1818, imposition of martial law driving several businesses to what is now Lubec village. The agreement formally restored Maine lands taken by the British, but it took time for reality to match treaty.

Even then disputes remained. The 1842 Webster-Ashburton Treaty attempted to resolve several border issues between the United States and the British North American colonies, including the location of the Maine–New Brunswick border. By this time, most easterly West Quoddy Head appeared securely within the U.S. border, yet in 1892 the United States and the Dominion of Canada were "more accurately marking the boundary line between the two countries in the waters of Passamaquoddy Bay" as discussed at length in *Maine in the Northeastern Boundary Controversy*. Final agreement came in 1918.

Alternative Claimants to Easternmost Point Status

Some claim that the nation's easternmost point lies in Alaska's Aleutian Islands, which cross the 180th Meridian but not the International Date Line. This concept places "east" at a specific longitude where, despite Rudyard Kipling, east and west do meet.

Stories from the Easternmost Point

Wikipedia says that the 180th meridian "is common to both east longitude and west longitude. It is used as the basis for the International Date Line."

Conventionally, we think of east and west both as absolutes and as directions—the Deep South, the Northeast, "out West." Face north and your left side is west, your right side east. Travel east in the United States, and you terminate at Quoddy Head State Park in the town of Lubec.

Welcome to the easternmost point.

WEST QUODDY LIGHTHOUSE

Over two centuries and more, many a skipper or helmsman felt the surge of deliverance on first spotting the Quoddy Lighthouse, guardian of the most easterly point of the United States. Its fear-mitigating presence began perpetual vigil from West Quoddy Head in 1808. The "West" Quoddy name paradox arose because "East" Quoddy Head lies farther east and a dozen miles north on Campobello Island, outside the U.S. border in Canada.

For 180 years, 1808 to 1988, brave and stalwart men and women stood steadfastly at their storm-whipped posts, warning mariners of the battered basalt-bound coast. Automation proceeded in 1988, the light flashing around the clock and the horn sounding when triggered by fog sensors. Early navigators petitioned for protection from the treacherous tombs of rocks waiting patiently for the errors of men. Help came, as so often, from prominent people of the region.

Colonel John Allan, Revolutionary War hero who settled on a farm in North Lubec, and Hopley Yeaton, a Revolution-era sea captain and later customs officer with the U.S. Revenue Service, now remembered as "Father of the Coast Guard," added their eminent names to the quest for a light. Their clout lent substance to the seamen's plea, eliciting an appropriation for a light station at what was then called Passamaquoddy Head.

By 1801, Secretary of State James Madison became concerned about clarifying the U.S. border. Yeaton's desired lighthouse at West Quoddy Head would serve dual purposes: navigation and a political statement that this is United States land.

"Maine was not yet a state when Congress authorized $5,000 in 1806" reads a Bureau of Parks and Lands document. "By its completion in 1808, it perched on Maine's coast [then part of Massachusetts]." By building a lighthouse at this remote but pivotal point of land, Congress confirmed the

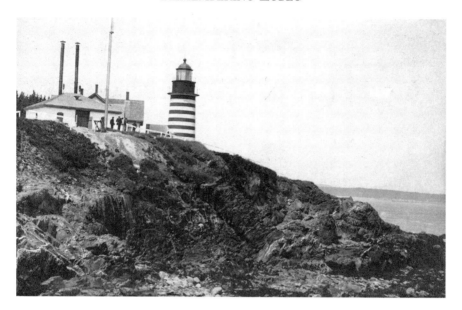

West Quoddy Head Lighthouse circa 1895. *Lubec Historical Society.*

ominous, shattered brow of this seemingly insignificant brink of coast as part of the United States.

Fog

West Quoddy Head, like Boston Light, utilized a fog cannon to warn mariners away from dangerous Sail Rock nearby. Then in 1820 the station received one of the nation's first fog bells, generating much additional work. Congress passed legislation in 1827 that stated that "the keeper of Quoddy Head Lighthouse, in the State of Maine, shall be allowed, in addition to his present salary, the sum of sixty dollars annually, for ringing the bell connected with said lighthouse, from the time he commenced ringing said bell."

The typical bell (shown on the next page), long on display but never used at West Quoddy, bears the inscription, "U.S. Light House Service McShane Bell Foundry Baltimore MD 1900."

In July 1827, Solomon Thayer, the local customs collector and lighthouse superintendent, complained that the 500-pound fog bell was inadequate. "It is of the utmost consequence to the commercial interests of this part of the country that the Bell at West Quoddy be made to perform its office," he wrote. Over the years, four different fog bells were tried at West Quoddy, the

second 241 pounds and the third 1,565 pounds, but all of them were difficult to hear offshore. For a time, an unusual fourteen-foot cast-steel triangle was tried in place of a bell.

Never satisfactory, powered fog signals eventually replaced mechanical bells. At one time, a coal-fired hot-air engine in the small 1857 brick utility building blew a trumpet-like device when fog settled on the sea. In 1868, an eight-inch steam whistle replaced the trumpet. Steam-powered apparatus enabled a ten-second blast at fifty-second intervals. By 1877, a duplicate steam whistle spread machinery into auxiliary buildings.

In 1887, all of the apparatus related to the duplicate fog signal were consolidated in the remodeled brick building on site today. Later, during a particularly foggy year, the two ten-inch whistles were in operation 1,402 hours, consuming sixty-four tons of coal.

That year was 1888 according to a handwritten transcription from annual reports of the U.S. Lighthouse Board. These records show that from 1885 to

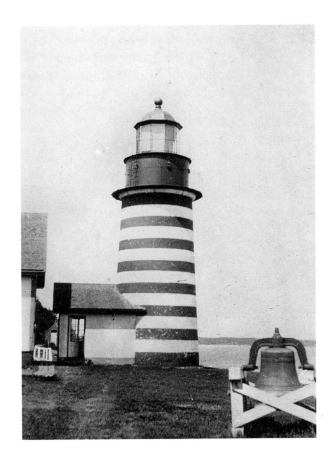

West Quoddy Head Lighthouse and early U.S. Lighthouse Service bell. *Lubec Historical Society.*

1907, only in one year did the fog warning run less than 1,000 hours—975 hours in 1902. The top was 1885, running 1,945 hours.

The Third and Final Tower

A great era of lighthouse construction worldwide was initiated in the 1850s. High technology of the times developed Fresnel lenses, efficiently concentrating light toward the horizon for maximum visibility. The new 1857 West Quoddy tower received such a lens from Paris, together with a spiral iron staircase. Many new lighthouses replicated the style, creating family resemblances among these beacons of hope and safety.

The U.S. Lighthouse Board adopted modern maritime-friendly practices. Evolving technology dictated brick towers, Fresnel lenses and cast-iron framing for the lantern assembly. All of these advances, and an octagonal copper dome with cast-bronze ball for the top, were applied to the new West Quoddy Light Station. "The lantern appears have been imported from France along with the Fresnel lens," according to United States Coast Guard (USCG) architect Marsha Levy. She wrote, "The lens (and probably the lantern) was manufactured by L. Sautter of Paris, one of the three French companies that had a monopoly on the production of Fresnel lenses."

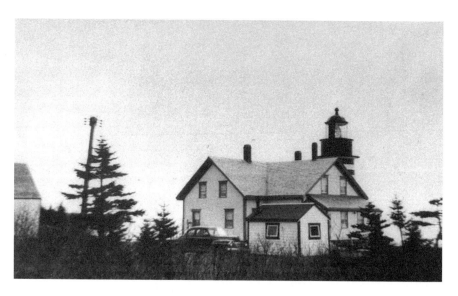

Lighthouse circa 1950. Note the automobile parked near the house. *West Quoddy Head Light Keepers Association Collection.*

Accelerated tower replacement encouraged bulk acquisition. Architect Levy continued:

> *Major components of the lantern at West Quoddy Head appear to be identical to a lantern and lens assembly imported from France in 1855 and installed at Point Loma Light, near San Diego, California. The dimensions and design of the cast iron lantern framing members are identical to those at West Quoddy Head, and Sautter also manufactured the Point Loma lens.*

Similar lanterns and components mark other west and east coast lighthouses of the era.

The photograph here shows the lighthouse a century later, looking much the same as in 1857 except with addition of a kitchen lean-to at the rear of the light keepers' house. Note the ever-present painted stripes and the shielding of the light from the upstairs bedrooms.

Those Stripes

Lubeckers become testy when faced with inaccurate representations of "their" lighthouse. Fifteen stripes, eight red and at top and bottom. A 1995 letter to lighthouse preservationist Ken Black from Commander J.R. Sproat noted that "the number of stripes has varied from 7 red and 6 white stripes to 8 red and 7 white stripes." Red is *always* on the top and bottom. The earliest available photo shows the usual fifteen stripes, with red and white the assumed colors. Note the tower-mounted bell, rung by clockwork as weights descended.

The Lens and the Light

Preceding the twentieth century, fire lit all lighthouses. Weak oil lamps, commonly fueled with whale oil, burned the lantern while shiny metal reflectors focused the feeble light toward the horizon. Light keepers carried oil, trimmed wicks and polished the reflectors. Many reflectors used to span coverage of three hundred degrees or more and demanded multiple lamps.

Solid glass lenses originated before 1600 but became burdensome in large sizes. Enter Augustin Fresnel, French physicist and mathematician, whose computations of optical refraction suggested manufacturing lenses in segments. Today's Fresnel (fray-nell) lenses are used in directing lighting

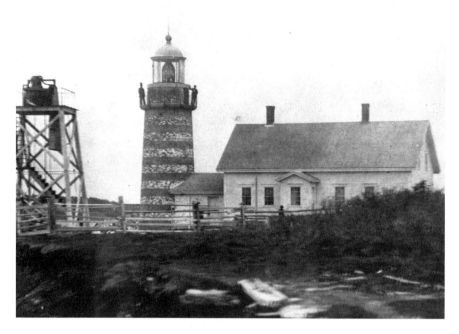

An early lighthouse photo. Note the mechanically actuated fog bell atop tower with clockwork weights. *West Quoddy Head Light Keepers Association Collection.*

from theatrical spots and in auto taillights with molded segments, making it a thinner, lighter lens. For lighthouse purposes, the ease of forming individual glass segments into iron-framed cylinders saved weight.

Even so, West Quoddy's "third order" Fresnel—four feet, eight inches high and over three feet in diameter—weighs a ton, and it's not even the largest. That honor, the "first order" Fresnel, measures seven feet, ten inches high and six feet diameter, almost like a walk-in lens.

Fuel for the Lantern

Development of the cylindrical Argand wick improved airflow, brightening the flame. Colza oil replaced whale oil in the early 1850s, but U.S. farmers' lack of interest in growing this crop caused a switch to lard oil in the mid-1850s. Discovery of petroleum and development of refining introduced kerosene in the 1870s. According to an article in *Lighthouse Digest* magazine, the Light House Service built small brick or masonry storage houses starting in the late 1800s and early 1900s as protection from fire. Many old photos

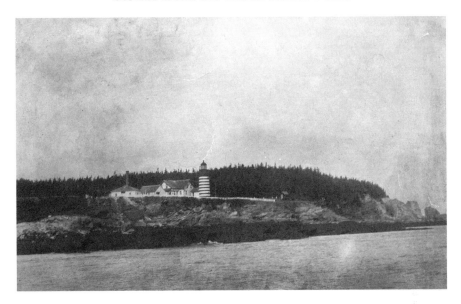

Offshore view showing the oil house located at a distance for fire safety. *West Quoddy Head Light Keepers Association Collection.*

show West Quoddy's eight-and-a-half-square-foot 1892 brick oil house, positioned safely at distance, complete with walkway. The new and seemingly endless petroleum became the fuel of choice. The Light House Service had totally converted by the late 1880s.

Electricity changed everything. An exhibit at the Visitor Center museum, prepared under the aegis of the Maine State Museum, says that West Quoddy was electrified in 1932. West Quoddy's Fresnel lens now magnifies and concentrates the beam from a one-thousand-watt light bulb—the same Fresnel lens hauled to the top back in 1857.

That lens remains constant, though over the decades fuel evolved and outbuildings came and went. Barns, workshops, boathouses and slips necessary for the delivery of fuel and other supplies by sea were erected. Few photos show boathouses. The rare image here apparently shows one example.

The First Tower

The Boston *Columbian Centinel* newspaper solicited bids for construction of the new lighthouse on June 18, 1807:

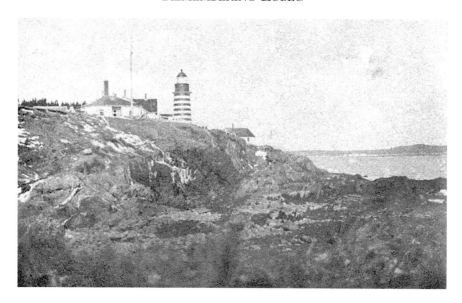

In this undated photo, a possible boathouse is located partially down the cliff. *West Quoddy Head Light Keepers Association Collection.*

The octagon Pyramid, of wood is to be of good oak, or white pine timber, without sap, and to be twenty-five feet diameter at the commencement. The height of the Pyramid to be forty five feet from the stone work, to the floor of the lantern, where the diameter is to be nine feet. The frame to be covered with good inch seasoned white pine boards feather edged, over which is to be laid a good coat of cedar or white pine (without sap) shingles and to be painted with three coats of good paint, the last two of which to be white.

Some 1,600 words provided detailed specification for contractors. The artist's rendition here, prepared before the text of the bid became available, is remarkably accurate. Two windows were specified, and even the number of panes is exact. The major discrepancy: lack of a vent atop to disperse the lamp smoke.

Low bidder Beal & Thaxter of Massachusetts completed construction of the tower in July 1808 for $4,800, $200 less than authorized. Below budget in only a year. The exact date of first illumination is lost to history. "The light-house at West Quoddy has been finished two months, but cannot be lighted for want of wicks," reported the Eastport, Maine *Sentinel* on September 8, 1808. Ancient documents describe an eight-sided wooden tower of indeterminate height.

Artist's rendering of the first tower.
Eileen Fitzpatrick.

The Second Tower

A limited life span doomed that first tower. Wood rots, especially wood exposed to the raging elements of Maine coastal waters. Sometime about 1830 masons erected a new tower of stone rubble. Hastily it seems, for subsequent keepers complained of leaks and disintegration.

The 1837 artist's engraving here corresponds with the second light tower at West Quoddy Head, 1831–56. Though obviously a highly romanticized,

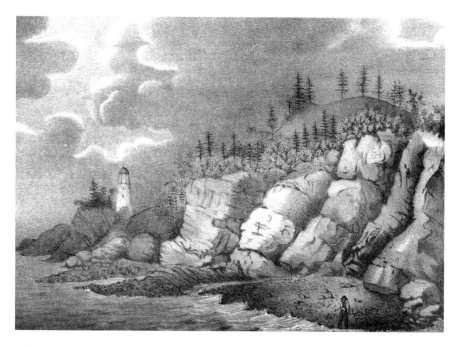

A dramatic etching of the second lighthouse tower. *Pike and Alden families.*

fanciful image, no other rendering of the second tower has surfaced. Sited in the image down the rugged embankment, the actual venue was on the open, level, grassy area above that crag-disfigured cliff, which offered an ideal elevated location for a lighthouse. The mound of earth northwest of the keepers' house defines its location.

The exact site of this tower is known from scientific excavation in 2001. The state archaeologist of Maine wrote, "I conducted that work in 2001. The work was done to test the areas where an electrical line and a drainage pipe were to be buried. We had a little time left so we tested the area of the earlier tower. In the report I called this the location of the 1808 and 1830 towers." Archaeologists uncovered no evidence of a wooden tower. The construction of the stone tower would have destroyed evidence of the wooden one if it had been at the same location.

The archaeologist continued: "The only artifacts found in association with the tower foundation were window glass, brick fragments, coal and slag, and of course a lot of stone fragments, many with white paint (whitewash?) on one side."

The rubble masonry was said to be leaky, with lime mortar so soft it could be penetrated with a knife. According to a document from the National

Archives, in 1855 the tower was "sheathed with wood, and shingled." The document adds that "Quoddy Head light-house requires rebuilding, and new dwelling-houses, and should be fitted for a third-order lens. For this purpose, $15,000 will be required." A year passed. As of 1856, "The lighthouse has been refitted with new and improved reflecting apparatus, which is designed to serve until suitable lens apparatus can be procured for a final refitment of them." The next year brought this action.

Automation

Growing reliability and declining cost of technology quelled need for a live crew. Inevitably, automation arrived, including weather telemetering by the National Oceanic and Atmospheric Administration. The termination ceremony took place on June 30, 1988, with last light keeper Malcolm "Mac" Rouse in attendance, along with retired Howard "Bob" Gray, who raised his family at this fabled site during a tour of duty from 1934 to 1952.

The U.S. Coast Guard turned over the property, including structures, to the State of Maine. Today, the Coast Guard maintains the lantern (the entire upper lamp assembly), while the State of Maine holds responsibility for those colorful stripes.

Despite radar and Global Positioning System (GPS), local fishermen and other mariners remain dependent on the old stone tower with its so-human characteristics of warning sound and light. Two seconds on, two seconds off, two seconds on, nine seconds off. The nautical map of West Quoddy shows "Fl (2) 15s 25m 18M." Translation: flashes two every fifteen seconds, tower twenty-five meters (eighty-two feet) high, visible eighteen miles.

Today's West Quoddy Lighthouse

Parks and Lands long desired a visitor facility, but one independent from the state. Local planning began in the early 1990s, the lengthy effort culminating in the nonprofit West Quoddy Head Light Keepers Association, Inc., which opened the tourist facility in 2002. The summer schedule—from Memorial Day to mid-October—drew over seventeen thousand visitors that first year, exceeding twenty thousand in 2007. As of 2008, registration showed guests from seventy-nine nations.

Seemingly all recognizing those red and white bands.

A SIGNATURE QUILT AND THE SEARCH FOR ROOTS

Signature quilts, sometimes known as autograph or memory quilts, became popular during the latter half of the nineteenth century. An 1889 signature quilt assembled in Lubec remained in the family and eventually returned to Lubec.

"I felt this quilt should come back home," said Ms. Betsey Leavitt Josselyn as she donated her family's signature quilt to the Lubec Historical Society. The late nineteenth-century quilt features squares autographed by women bearing the names Case, Calkins, Kelley, Woodward, Guptill and Small, all longtime Lubec families.

Quilting brought women of the nineteenth century together socially while engaging in work essential to their families' well-being, even survival. Beyond a quest for warmth during intense northern winters in an era heated solely by parlor and kitchen stoves burning wood or coal, the autographed signature quilts established permanent memories for those about to leave, perhaps to "go west" or enter marriage.

Consider the first square shown here, signed by Almeda J. Case (née Wormell). A pink fabric forms the ground of each autograph square, an off-white cross bearing the signature and often the year of completion. Mrs. Case's 1889 date indicates a few decades of technological progress developing "indelible" inks that tended to fade but neither laundered out nor damaged the fabric. Tannic acid in early indigo lampblack and iron sulfate–pigmented inks caused deterioration in cellulose fibers.

Betsey Josselyn said that the quilt, used daily in her parents' bedroom as a spread and later displayed on the traditional wooden quilt rack, fascinated her during childhood. Imagine the wonderment of dates from the 1800s for a wide-eyed youngster, faded but still legible.

Ultimately, Betsey inherited the quilt. She knew that her grandmother's family passed down the coverlet. Now she examined it more closely. Noting

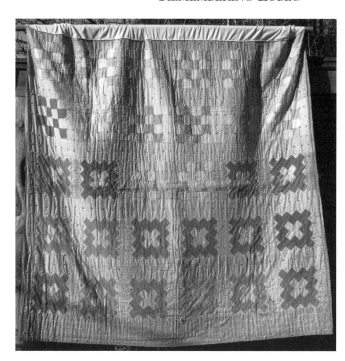

Left: The Lubec signature quilt, measuring about six feet square.

Below: The signature of Almeda J. Case. *Ronald Pesha.*

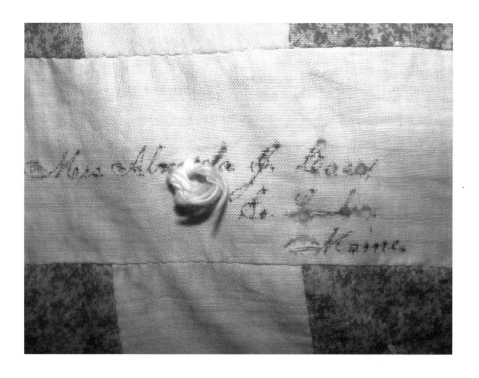

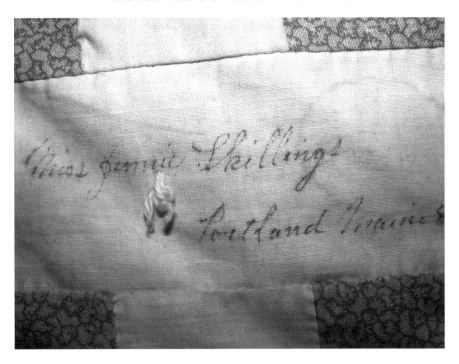

The signature of Miss Jennie Skillings. *Ronald Pesha.*

the signature Almeda Case, Betsey recalled hearing that name as a youngster. She scrutinized and then transcribed the other legible squares:

> *Rena Woodward April 13, 1888.*
> *Mrs. [?] Calkins West Lubec Maine 1889.*
> *Miss [?] Hillie Guptill, Lubec, Maine.*
> *Bertha M. [or W.?] Small April 7 [or 2], 1888.*
> *Miss [?] Collins West Lubec 1888.*
> *Miss Elsie Meyers Lubec April 25, 1888.*
> *Edna Calkins West Lubec.*
> *Miss Jennie Skillings Portland Maine 1889* [perhaps visiting from Portland].

A square with an unreadable name is dated "Lubec, April 25, 1888." Another leaves only "West Lubec" legible. Betsey Josselyn deciphered yet one more square as "Lottie Rolley," but the Lubec Historical Society suggests "Kelley" as the surname, long an established name in Lubec.

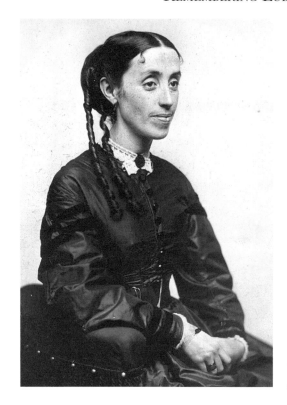

Wealthy Ellen Wormell. *Betsey Leavitt Josselyn Collection.*

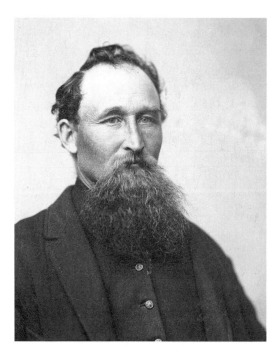

Loring Leavitt. *Betsey Leavitt Jossleyn Collection.*

Stories from the Easternmost Point

Betsey told of long family traditions, using and preserving heirlooms from teapots and dishes to handmade rolling pins and photographs. Her mother, Ellen, displayed nineteenth-century family photos all about the house. "I felt like I knew them," said Betsey. The paper prints and early tintypes were also bequeathed. "Who were these people with their strong New England faces?" She sought to clarify connections, however tenuous, between the many images and the heirlooms.

Her grandmother, Nora Leavitt Mahoney Hanson, was born on South Lubec Road on the edge of the sea, a family tied by location and tradition to maritime endeavors, including the lighthouse at West Quoddy Head. Her mother, Lulu Ellen, died when Nora was two. Nora then cared for by her grandmother, Wealthy Ellen Wormell Leavitt.

Wealthy Ellen would marry Loring Leavitt, probably the Lubecker working as assistant West Quoddy Lighthouse keeper from 1861 to 1867. Later, in 1883, Leavitt joined with other local entrepreneurs in the burgeoning Lubec sardine industry, opening a South Lubec factory. (Most sardine processors were in North Lubec and the central business and residential area often called the "village.")

The two were great-great-grandparents of Betsey Leavitt Josselyn.

Wealthy Ellen's father, Ebenezer Wormell, served as keeper of West Quoddy Head Light in the 1840s and 1850s. Eben sired a large family that included six daughters. Selinda Wormell died in 1862, but the living five were photographed in that stout formal manner of the era against a faux floral background by a tintype artist circa 1885.

Among the Wormell sisters sits Almeda J. (Wormell) Case, who autographed the quilt so resolutely in 1889. Posed stiffly and unsmiling for the lengthy exposure time required for tintype photography, Betsey Josselyn perceives the five appearing older than their calendar years. Betsey's grandmother fortunately inscribed their names on the rear side of the image: Wealthy Ellen Leavitt, Mary Elizabeth Marston, Almeda Case, Eliza Ann Marston and Clarinda.

"The Wormell Sisters tintype was always a childhood favorite of mine as it sat on our family mantle." It now resides above Betsey's living room fireplace. This tintype became the link, the bridge, that connected quilt, antiques and other artifacts into a cohesive construct of family past.

Betsey Josselyn felt impelled to retain most family heirlooms but grasped the quilt's genesis in Lubec. Unlike manufactured goods, the quilt's creation came about within a circle of Lubec women, their handwork birthing folk art now widely admired. Betsey determined to share her childhood's wide-eyed wonder and gave it for public exhibit in its new Lubec home.

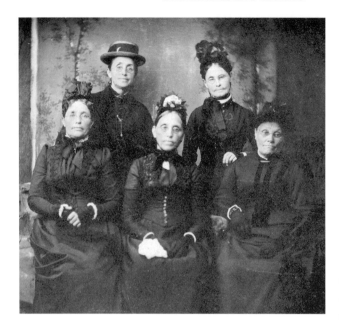

The five Wormell
sisters. *Betsey Leavitt
Josselyn Collection.*

Josselyn, who lives in Massachusetts, first visited the Lubec of her maternal ancestors as a child in August 1958. The photograph from that visit clearly shows the South Lubec Road beach and mud flats, the water of Lubec Channel and Campobello Island, New Brunswick, unmistakable across the channel waters.

As an adult, Betsey traveled to Lubec, repeatedly researching the family at the town hall and the cemeteries to fill in some of the blanks and construct a family tree. Facts plus memories often marry information with faces.

Betsey related unsuccessful attempts to find the house pictured on the facing page, no longer extant. Family album photos reveal other houses, presumably in the neighborhood, which still stand, including the stately Victorian house here with its recognizable two-story bay window. In the background, at 328 South Lubec Road, lies a house coincidentally sitting next door to this author's house. Betsey Leavitt Josselyn had found, if not the actual residences, the very grounds home to her ancestors a century back in the family timeline.

The Victorian appears frequently in the family album, one photo bearing the penciled notation, "Lubec Summer House." Betsey's grandmother, Nora Leavitt Mahoney, and her brother, Paul, were there, cavorting in period clothing on steps outside the south end of the house about 1915.

The next photo features Betsey's grandmother Nora (on right) and a friend (on left) also costumed in period clothing. "Grandmother told me that they pulled this sailor off the street and had him pose with them"—which leads to

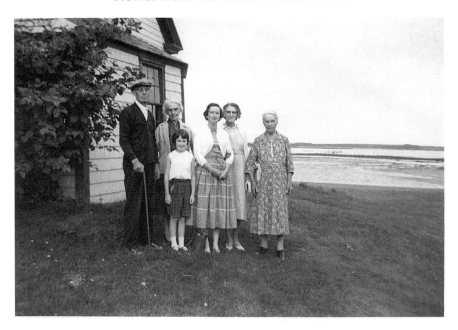

The Godfrey house, located in South Lubec. Note Campobello Island in the far background. *Left to right*: Arthur Godfrey, his sister Elizabeth (Lizzie) Godfrey, young Betsey Leavitt Josselyn, her mother Ellen H. Josselyn (daughter of Nora Leavitt Mahoney Hanson and Gordon Clark Hanson, originally from Machiasport), Abbie Hanson and the last Godfrey sister, Edith. *Betsey Leavitt Josselyn Collection.*

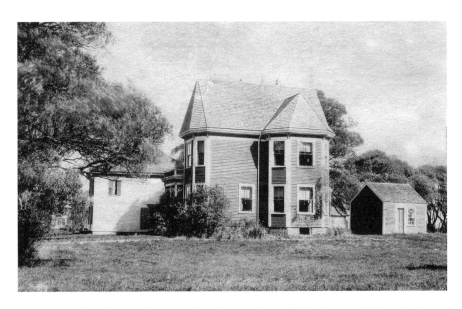

The South Lubec Victorian house, with a "summer house" in background. *Betsey Leavitt Josselyn Collection.*

Playing dress-up circa 1915. *Betsey Leavitt Josselyn Collection.*

ponder the inevitable yet unsolvable questions in historical research. Was he actually a navy sailor or perhaps headed to or from the station maintained by the U.S. Coast Guard in that era, when the old Light House Service supervised the West Quoddy Light Station?

A more pertinent question surrounds the ancestry of the quilt. What might have happened in 1888–89 in Lulu Ellen's life for her to be in possession, probably from a gift, of the quilt? Betsey feels uncertain that it came to her grandmother from her mother. It may have been Wealthy Ellen's, as her sister Almeda made a square. The quilt may have been an engagement present for Betsey's grandparents, Lulu Ellen and Eugene Mahoney, who were married in 1891.

Growing up in a small New England town settled by her father's people, Betsey experienced the roots common in close-knit communities with stable

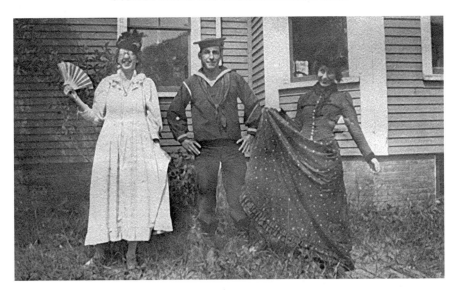

Victorian garb outside Victorian house, circa 1915. *Betsey Leavitt Josselyn Collection.*

family roots extending back generations and even centuries. She knew that her maternal grandparents were from the coast of Maine. "My grandfather went to sea as soon as he could and the roots from those coastal Down East towns called to me too. I grew up with my grandparents close by and I listened and absorbed the details of their lives."

Now the oldest generation on her mother's side, Betsey lovingly and gently runs her fingers over these heirlooms and wishes she had listened more and asked more, enhancing her curiosity. She expresses solace in finding the facts, preserving the past and becoming trustee of its treasures.

When Betsey helped sort her mother's things after her death, some of the family's precious possessions made their way back to the maternal grandfather's childhood home in Machiasport, Maine. Gordon Clark Hanson worked for the U.S. Life-Saving Service early in his career before he became a sea captain, a scion of seafaring traditions shared by so many stalwart, forthright inhabitants of seagoing communities. The family now shares his home as a vacation venue. With Betsey as steward of the quilt, she saw it safely to Machiasport, wrapped carefully with intentions of getting it to Lubec someday.

She did. The quilt now resides in darkness, viewable only in dim light away from sun, at the Lubec Historical Society. Transported home to Lubec and shared with all who wish to examine the Lubec signature quilt.

BUILDING PRESIDENT FRANKLIN ROOSEVELT'S BRIDGE

Well, it's not exactly his bridge, though it is named in his honor. Campobello, a fifteen-square-mile Canadian island in the Bay of Fundy and site of Roosevelt's longtime summer home, lies ten miles across open ocean from mainland New Brunswick—and 290 yards by the bridge from the U.S. mainland at Lubec, Maine.

In the late nineteenth century, the leisure class made fashionable the remote, rustic Campobello Island in New Brunswick, Canada. Life seemed more blessedly relaxed than the established watering sites of Long Island's Hamptons in Newport, or even Bar Harbor. And far cooler, for even the Rhode Island and southern Maine shores offered limited respite during August heat.

Franklin Roosevelt on Campobello

As moving the family for months of summer rustication became vogue, Franklin Roosevelt's parents bought property in posh Campobello in 1883. Here the only child learned the customs of class and the appeal of nature and sailing the sea. Here Roosevelt later brought his bride, Eleanor, moving into their own thirty-four-room "cottage" in 1909. Every year Eleanor and their five children enjoyed tranquil summers while FDR sweated in Washington as assistant secretary of the navy under President Woodrow Wilson, joining the family as time permitted.

The Roosevelt family felt no need for a bridge. They arrived at their personal dock via ocean cruise or boated across the two-mile Passamaquoddy Bay from Eastport, Maine's train terminal. The Narrows between their beloved island and Lubec merited not a second thought. However, the assistant secretary considered himself competent to pilot through the narrow passageway frequented by ferries and fishers of herring.

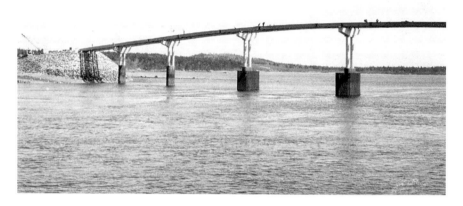

The beautiful span of the Franklin Delano Roosevelt Bridge. *Lubec Historical Society.*

Lieutenant William "Bull" Halsey commanded the *Flusser*, a destroyer returning the assistant secretary of the navy to his Campobello home after an inspection of naval installations along the Maine coast. Rather than the usual ship route around the north end of the island and through the channel thirty meters (one hundred feet) deep, Roosevelt chose, indeed insisted, on piloting the destroyer through the Lubec Narrows.

Actually, the Lubec Narrows ship channel became ready four decades earlier. According to the 1888 *Eastport and Passamaquoddy*, during the 1880s George Robbins "devoted a good deal of time and effort" to widening and deepening the ship channel through Lubec Narrows. Robbins secured legal action and appropriation from Congress for surveying and dredging, completed by 1884.

A World War I–era, seven-hundred-ton destroyer was far smaller than modern warships. The *Flusser*, at 294 feet in length, with a beam of 26 feet, drew only eight feet of water compared to the Narrows' dredged minimum depth of 17 feet. But the 150-yard minimum width spelled potential trouble for a 100-yard-long vessel, even without a bridge to interfere. Halsey's biographer relates an account of the incident, pointing out that "on a turn

two-thirds of a destroyer is aft of the pivot point, so that the stern swings on an arc twice as wide as the bow arc." While the bow appears properly on course the stern may be in trouble. Halsey watched as Roosevelt turned the wheel, then looked aft to check the stern swing and knew he had a winner at the wheel. "Mr. Roosevelt was a splendid looking, vigorous man," said Halsey in retrospect, "full of vitality."

Polio

Eight years later in 1921, also at Campobello Island, polio struck the thirty-nine-year-old Roosevelt, changing his life forever and perhaps altering history.

He did not return to Campobello for thirteen years, and then as U.S. president, during a state visit following the fabled first hundred days. Only twice more would he visit the island, both during the 1930s, the final trek a mere day trip.

During that decade, Eleanor returned more or less regularly, often driving to Lubec herself with just her secretary, parking in the town garage and ferrying across the Narrows. On both sides of the border, residents relied on the New Brunswick–funded ferry, a tug-pushed scow with a capacity of eight passenger vehicles.

Declining Prosperity

Though popularity of remote Campobello declined as the twentieth century grew, the Roosevelts treasured the tranquility, holding their property while others fell into shabby disrepair. Eventually sold by fourth son Elliot, the cottage was eventually deeded by donation to both Canada and the United States. Ultimately, as an international park unique in the world, its significance draws diverse devotees of history from much of the globe—nearly all crossing the Franklin Delano Roosevelt Bridge and boosting a tourism economy.

The Bridge Underway

Fifteen firms from both the United States and Canada bid to build the bridge, the lowest figure coming from Callahan Brothers of Mechanic Falls, Maine. Clayton MacDougal of the Maine Highway Commission and

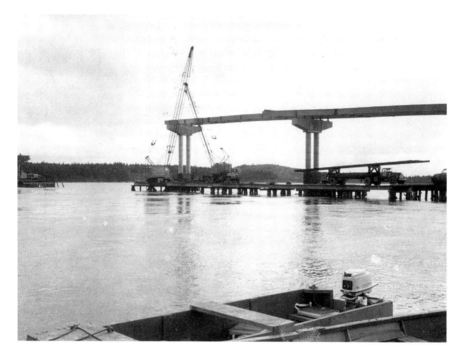

The unusually slender piers of the bridge. *Lubec Historical Society.*

the corresponding official from New Brunswick, Hugh Walford, were the chief engineers—yet another example of the long history of international cooperation that has existed between the two nations.

Elegant design characterized the new bridge. Jim Chandler, an engineer and inspector on the two-year project, pointed out that the pier columns are unusually slender from the shaft to the caps on which the steel beams and concrete deck of the superstructure rest.

The beauty of the bridge masks its utilitarian nature, for it physically connects two communities in different nations already close socially. "The people of Lubec had wanted a bridge for years" noted *Better Roads*, a Maine periodical. The Campobello Island residents, too, felt eager for the bridge, which would allow easy access to the mainland merchants and movies and even marriage.

Families do intermarry; family names centuries old mingle across the border. The nations share firefighting facilities, and even telephoning across the international border is a local call now. Campobello residents drive to Lubec for gasoline. With no source for medical prescriptions on the U.S. side, Lubeckers trek to Campobello's pharmacy. The bridge bonds the two border communities.

Designing the Bridge and
Preconstruction Preparation

The bridge design, by Maine State Highway Commission engineers (now Maine Department of Transportation), is necessarily unique. Below high tide, which can reach and even exceed twenty feet, the piers' shafts above the foundation are protected by wrought-iron shells. These shells served as forms in which to "place" or pour the concrete. Wrought iron resists deep corrosion better than other irons and steel.

The Maine Highway Commission engineer arrived in late 1960, setting up offices in an old barbershop (possibly the old John Trenholm place on the left side of Washington Street, Highway 189, not far from the entrance to the bridge). Before the bridge proper could be erected, shore preparation and approaches were built. Those approaches are filled with crane-laid riprap.

The international agreement provided that half of the labor and half of the materials would originate from each of the two nations. According to Inspector Jim Chandler, sand and stone for the concrete abutment, piers and

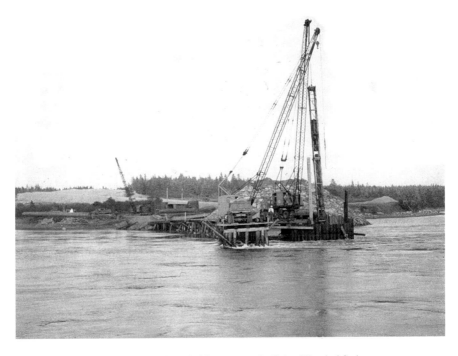

Building the Campobello side of the bridge approach. *Lubec Historical Society.*

superstructure on the Canadian end of the bridge came from Campobello's Wilson's Beach. The contractor found that one end of the beach was sand, uniformly graded, and that the other end shifted from small stone to large stone to very large stone. "The wave action must have done that over the years," said Chandler. "It was truly amazing." The contractor could excavate a specific section of the beach to get just the right size material that was specified for the concrete mix.

The concrete aggregate on the Lubec side came from a cove in South Lubec. "It wasn't particularly unusual," said Jim, "just another beach." Sand and gravel borne by water do separate and settle naturally into formations on seashores—thus gravel bars. Even the indigenous population coined appropriate language: *amkiak*, a well-known word for a gravel bar in Micmac, Maliseet and Abnak; and *Kepam'kiak* translates to a bar of gravel in Lubec, near the ferry to Campobello. Locals know the site.

Bridge Building Hazards

Lubec Narrows connects with Bay of Fundy and Passamaquoddy Bay, all open sea. Strong riptides develop on the Narrows under the bridge, reaching

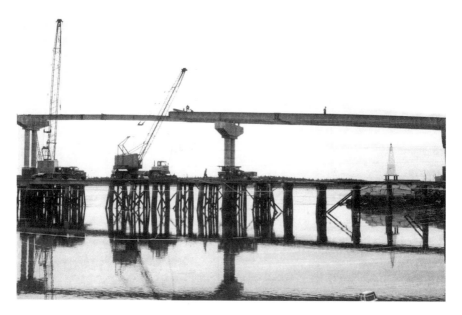

Note the heavy vehicles on the trestlework (below), the bridge (above) and the small figures of workers. *Lubec Historical Society.*

up to ten knots or about twelve miles per hour, with a tidal variation approaching twenty feet on a twice-daily cycle. A *Boston Sunday Globe* article wrote that "only a bridge-engineer can appreciate the problem of building caissons for pouring cement in such fast-rushing icy waters."

As an inspector, Jim Chandler spent hours down in the holes with workers while that rushing tide swirled past on the outside, causing the whole cofferdam to vibrate. "Looking back on it," said Jim, "it was really scary, as was walking along the narrow beams seventy feet above low water."

A Canadian worker did fall from the bridge during one incoming tide. Contractor Dan Callahan ran from the bridge approach up Lubec's Water Street about two hundred yards, jumped into a small boat at the town landing, rowed out and grabbed the man, saving his life. "I stood at the work site with a feeling of helplessness and watched the whole drama," said Jim. No one was lost or seriously injured on that day or any other, a remarkable record for building a bridge in North Atlantic waters considering the ferocious conditions in the Lubec Narrows even on a good day.

The Capsized Boat Incident

On another day, an ebbing tide appeared normal, but a sharp wind developed without warning. It was a cold October day in 1961, with a higher tide than normal, as occurs near a full moon or new moon. A new moon occurred on Monday, October 29, 1961. The photo here, snapped the day before the new moon on October 28, shows the state of trestlework at that point. "The current through the Lubec Narrows was ripping, and the wind whipped the water into furious state, dark with frothy white caps," said Jim Chandler.

The crew, on the Campobello side, wisely halted and prepared to abandon work for the day. Two boats routinely ferried workers across the narrows. One was a dory owned by a Campobello resident. The other—a Callahan Brothers flat-bottomed, square-bow skiff—was operated by one of the contractor's crew. "There were often subtle remarks about which boat was more suitable," said Chandler. It seems that the landlubbers generally thought that the flat-bottomed vessel was safer. The locals, seasoned by the sea and its vagaries, had no doubt that the dory was much more seaworthy.

Everett Barnard and Jim Chandler, both carrying transits, boarded the flat-bottomed boat with some Canadian workers to cross the choppy waters toward the Lubec landing, but the dory following them lost power. The Callahan boat operator slacked off the engine, and a worker threw a rope that became entangled in the outboard engine of the flat-bottomed boat and

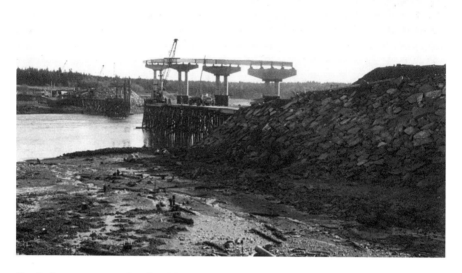

Day before new moon, October 28, 1961. Note mud flats visible during low tide. *Lubec Historical Society.*

disabled it. "The current swept our boat close to the work trestle," related Chandler with a still-lingering remnant of apprehension. By then, the dory operator managed to restart the engine. The Callahan Brothers boat hit the trestle with a sharp jolt, which turned the small vessel up on its side, the bottom rammed firmly against the wood piling. The Canadians scrambled onto the trestle, never getting their feet wet. Chandler and Barnard, holding the valuable surveying gear for which they bore responsibility, went over the side into the cold, rushing seawater.

Locals say that if you fall into an outgoing current you end up in open ocean. "Remembering that caution, I had dropped my surveying instrument before I hit the water," said Chandler. "It seemed a long time that I was underwater, and I remember thinking this might be my time." But he surfaced under the trestle seconds later. While hanging on to the trestle, waiting to be rescued, he watched the dory dock at the Lubec boat landing and unload most of the workers.

After a time, the crane operator, who had stayed behind fearing to cross the channel in the stormy waters, lowered a cable and pulled a soggy, shivering

Jim Chandler up to belated but very welcome safety. Meanwhile, Everett Barnard, still grasping his transit, held desperately to the last piling on the trestle. The emptied dory returned to the down-current side of the trestle to rescue Everett. Gently passing the transit into the dory, he boarded and then clasped the instrument firmly. But would you believe it? A rope that had been passed to him from the deck caught the transit and yanked it from Everett's grip, out of the boat and into the water.

Ropes seemed to cause most of the problems that day.

The group headed back to the boardinghouse to get warm and dry, and the chief engineer, McDougal, "gave us both a stiff drink of Canadian Club," Jim said. Lubec's Dr. MacBride had told him that was best after a dunking. "It tasted good to me, but Everett had to take it like medicine."

The phenomenal range of Fundy tides boasts some advantages. At low tide the transits were readily located on the mud flat and retrieved for repair.

Inspector Barnard

Everett Barnard had arrived in Lubec about noon back on July 18, 1961, after the four-hour auto drive from his home near Waterville. The sun bore down bright and hot at ninety degrees until Everett entered Lubec's guaranteed and fabled fog about a mile from shore. At the job site he found Resident Engineer Bob Shailer sitting on a sawhorse and shivering in a winter coat. "I hope you brought some warm clothes," said Shailer.

Assigned to aggregate testing and concrete inspection duties, Barnard later became lead inspector for the approach roadway.

A Major Undertaking

The structure design needed to provide an automobile crossing of the Lubec Narrows, as well as allow for safe commercial and pleasure navigation of the channel for many years. The 880-foot, continuous composite bridge with 6 percent grade reaches 48 feet above water at high tide at the point of greatest elevation. "The high tides, rapid currents, and high velocity coastal winds presented some very tough temporary trestle construction and cofferdam work," explained Barnard. The structure also had to withstand the very harsh saltwater conditions in the Bay of Fundy. "This project offered experience in nearly every aspect of bridge design and construction that I would be faced with in the rest of my long career with the Department."

Eventually, Barnard headed the Maine Department of Transportation's Bridge Maintenance Division.

Erection of the Steel

Meanwhile, work continued through the winter. Clayton McDougal, resident engineer for the State of Maine, reported that he expected steel to be erected before 1961 ended, dependent obviously on the weather. *Maine Highway News*, published for employees of the Maine State Highway Commission, noted that once steel was in place the project would be suspended for the remainder of the winter. Pouring of the concrete deck would resume in the spring. The photo here shows the deck on May 7, 1962, nearly ready for concrete. Looking toward Lubec shows Washington Street, Maine State Highway 189, rising from the shore.

Finished at an estimated cost of $939,000, construction came in below budget. When the bridge opened for routine daily use, the international agreement specified that there would be no tolls.

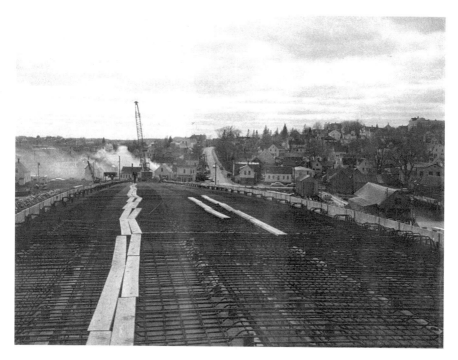

Bridge deck, looking toward Lubec, ready for concrete. *Lubec Historical Society.*

Dedication of the Bridge

A crowd of five thousand pressed forward to see the dedication of the long-awaited ribbon between two friendly nations. Lubec's small but superbly trained high school band provided music while the navy destroyer *John Paul Jones* was anchored in the harbor. Circumstances clearly pinpointed Maine state representative Sumner T. Pike as master of ceremonies. Davis Pike, a relative of Sumner, says that he was a "key mover" for both the building of the bridge and the passage of the bill to create Quoddy Head State Park. Davis added that for siting the American end of the bridge his father Carleton sold his shorefront dock property to the state for one dollar.

OFFICIAL OPENING

ROOSEVELT MEMORIAL BRIDGE

CONNECTING

LUBEC, Maine with CAMPOBELLO ISLAND

MONDAY, 13TH AUGUST, 1962

2.30 P.M., E.D.T., A.S.T.

Program

Chairmen:	SUMNER T. PIKE Maine State Legislature REV. N. P. FAIRWEATHER Chairman Bridge Committee NATIONAL ANTHEMS
Speakers:	His Excellency JOHN H. REED Governor of Maine HON. LOUIS J. ROBICHAUD Premier of New Brunswick HON. EDMUND S. MUSKIE United States Senator HON. HUGH JOHN FLEMMING Minister of National Revenue and Minister of Forestry for Canada
Ribbon Cutting:	HON. JAMES ROOSEVELT United States Congressman
Music by:	LUBEC HIGH SCHOOL BAND

NOTE: *In the event of inclement weather ceremonies will be held in—*
SOUTH SCHOOL GYMNASIUM

Program for the dedication of the FDR Bridge. *Lubec Historical Society.*

Obviously, everyone wished for Eleanor Roosevelt to cut the ribbon. The *Boston Globe* noted that "if a virus keeps 77-year-old Mrs. Roosevelt from coming to cut the ribbon…on the bridge which will finally connect this New Brunswick island with Maine, it will be as great a disappointment to her as it will be to the people here, for they are very fond of her."

Eleanor Roosevelt did attend the dedication, two months before her seventy-eighth birthday, but was weak from recent hospitalization. "I am sure you are anxious to know how the trip went," she wrote to her daughter. "Everything went smoothly and while I am feeling stronger all the time I imagine it will be quite a time before I feel entirely normal."

As the program reproduced here indicates, oldest son James Roosevelt actually cut the ribbon. However, Mrs. Roosevelt observed the ceremony from a car. She died less than three months later, on November 7, 1961.

The bridge remains, a working ribbon of steel and concrete intimately tying two communities in two nations into a single working relationship. Franklin Roosevelt would be pleased with his bridge.

REBURYING THE FATHER
OF THE COAST GUARD

I commanded the 125-foot cutter that bears his name, but I knew little about Hopley Yeaton, nor that he was buried in Lubec, Maine." In 1966, LDCR James G. Heydenreich of the U.S. Coast Guard first read about Hopley Yeaton. His accumulation of biographical information eventually led to reinterment of Yeaton's body from Lubec to an honored memorial at the Coast Guard Academy in New London, Connecticut.

Born circa 1739, Yeaton grew up around Portsmouth, New Hampshire, just south of the future Maine state line, where the sea beckoned the young men of the era. Improved public record keeping tells us that he married Comfort Marshall in 1766 and that of seven children only two survived—Samuel and Mary.

No known contemporary paintings of Yeaton exist. The painting here by Russel J. Buckingham Jr. hangs in Yeaton Hall of the Coast Guard Academy. (The academy pronounces the name as YEE-ton.)

With two decades before the mast by the time the smoldering American rebellion became a de facto revolution, Yeaton's mastery of the sea led to Revolutionary War service of commanding excellence. After restoration of peace, he captained a series of merchant ships and maintained friendship with John Paul Jones, Thomas Jefferson and George Washington.

Comfort died in 1788, and Hopley married Elizabeth Gerrish (1747–1819) in late 1789. Elizabeth bore him no further children, but as did Hopley she came from the area (Kittery, just across the Piscataquis River from Portsmouth), and she died in Lubec.

A month later, George Washington visited Portsmouth. The four-day stay, much of it spent with Yeaton, probably catalyzed Hopley's return to federal service.

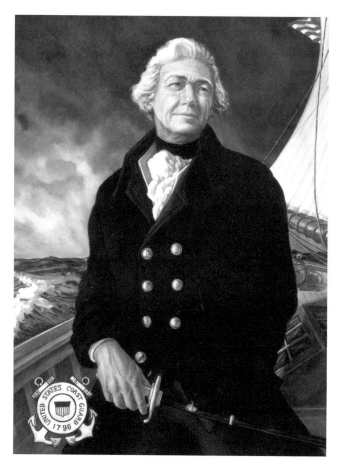

Hopley Yeaton. *U.S. Coast Guard.*

Revenue Cutter Service

Yeaton entered the two final decades of his life with a new career as the first commissioned officer in the newly formed Revenue Cutter Service. (Consider that the young nation's income was derived primarily from the collection of customs duties.) Smuggling abounded, especially on the distant down east coast of Maine, depriving the federal treasury of monies to pay off $80 million in debt. In those days, too, the federal government sought to eliminate obligations and achieve solvency.

Secretary of the Treasury Alexander Hamilton established the Revenue Cutter Service in 1790 and petitioned Congress for armed seagoing enforcement vessels. The first ten tiller-steered schooners of only fifty-one tons displacement boasted ten muskets and twenty pistols.

Yeaton's New Commission

The Revenue Cutter Service, under jurisdiction of the Treasury Department, functioned until 1915, when it merged with the U.S. Life-Saving Service to form the Coast Guard. The Continental army essentially disbanded, and the Cutter Service remained as the only military force until authorization of a navy in 1794. Hopley Yeaton became the first commissioned officer of the Revenue Cutter Service, thus today's distinguished designation as "Father of the Coast Guard."

Peter Boyce, owning the North Lubec site of the original Yeaton grave, is also a direct descendant of the third commissioned Revenue Service officer. Boyce owns the original document identical to one that commissioned Yeaton, bearing the same date. It reads, in part:

> *Reposing special Trust and Confidence in the Integrity, Trust, and good Conduct in Jonathan Maltbie of Connecticut, I do appoint him Master of a cutter in the Service of the United States, for the Protection of the Revenue; and to empower and authorize him to execute and fulfil [sic] the Duties of that Office according to Law; AND TO HAVE AND TO HOLD the said office, with all the Rights and Emoluments thereunto legally appertaining, unto him the said Jonathan Maltbie during the Pleasure of the President of the United States for the Time being.*

"G. Washington" and "Th. Jefferson" authorized the commission.

Yeaton Comes to Maine

The federal government established duties for goods arriving in its new nation, but lack of enforcement paralyzed collectors and enabled the taking of contraband as spoils. Yeaton settled his family in the city of Eastport initially. Soon he moved his family to Seward's Neck, an active farming community that later became North Lubec, where he acquired a one-hundred-acre land grant for a new home. Neighbors included Colonel John Allan, also an important Revolutionary War leader, and Louis Delesdernier, Lubec collector of duties. The adjacent Johnson Bay offered ample room for his own dock, Constitution Wharf, where he moored his cutter *Scammel* during those rare times when he and his crew were not running down lawless smugglers and forcing duty payments.

An anarchy of smuggling erupted via plundering picaroons, and Yeaton honed his skills from Eastport to Lubec and farther south with mounting success. The year 1896 showed a decline of the federal debt and an increase in the professionalism of the Revenue Cutter Service. An article in *Down East* magazine said that Yeaton "influenced the shaping of the Revenue Service in such matters as the training of young officers at sea and the establishment of aids to navigation."

Lubec and a Light

Wary of the lurking breakers and jagged, grinding entrance to Lubec Channel, Yeaton sought a lighthouse aid to navigation for sea dogs like himself, as discussed in the second chapter. What satisfaction must have suffused through his elderly being when the desired lamp first lit its arrow of safety in 1808!

Yeaton also took great interest in the separation of Lubec from Eastport. His son, Samuel, was among the signatories of the petition requesting separation. Records show that Hopley attended the first meeting of the new town on July 29, 1811. Voters elected Samuel Yeaton as officer of the Middle School District.

The Last Battle

To fight Napoleon, England often shanghaied sailors or "impressed" them—the victims are forced into military service by an antagonistic nation. The Jefferson Embargo of 1807 sought to avoid American involvement by forbidding all international trade by Americans—an engraved invitation to smugglers. The unsuccessful and short-lived embargo failed to deter Yeaton, almost seventy, from running down fourteen hijackers on an already-confiscated cargo boat and capturing all with an open exchange of fire.

This action failed to end smuggling. For decades warehouses and wharves prevailed on Campobello, filled with British and West Indies merchandise, which subverted duty during exchanges for money, foodstuffs and other goods.

Yeaton, though, having established a tradition for the Revenue Cutter Service that outlasted its 1915 transformation into the Coast Guard, eagerly embraced retirement. He lived to witness another personal goal: the establishment of Lubec. Death claimed Yeaton on May 12, 1812. His family buried him on the farm he loved.

Exhuming the Remains

It is Friday, 1 November 1974, 0800. Five Coast Guard Academy cadets under Commander James Woods and officials from the First District assisted by locals commence disinterment.

The road to Lubec began in 1944 when *Lubec Herald* editor Harry Keene wrote to the Coast Guard public relations officer Sidney Cullen. Keene, from a Lubec highly dependent on the service for its lighthouse and its fishermen's safety, requested publicity material about the Coast Guard anniversary on August 4. Perhaps even about the Father of the Coast Guard.

"Who?" responded Cullen.

"Hopley Yeaton," answered Keene. "He's buried out at North Lubec on the family farm."

Cullen, later editor and publisher of the Rockland, Maine newspaper, related the sequence of events in a 1972 *Bangor Daily News* article. "The Coast Guard Station at West Quoddy Head was ordered to locate the grave and to prepare it for proper ceremonies on the anniversary date."

Ken Black, chief warrant boatswain of the Rockland Moorings, became interested. A 1959 *Bangor Daily News* edition displays a picture—"Group

Breaking ground. *U.S. Coast Guard.*

Commander Kenneth Black of the Quoddy Head lifeboat station" placing a Memorial Day wreath on the grave. In a 2004 letter to this author, Black said that others, including Commandant of the Coast Guard Academy Admiral Chester Bender, "became involved in plans to erect a suitable memorial at the Academy." The journey began.

Spades and a pickaxe reached four feet, and then a probe struck wood. Gentle removal of remaining soil revealed the coffin's loose top. Local reporter in attendance Shirley Morong wrote that "the inner side of it resembled a smooth, beautifully grained counter top recently finished." Clatyon Beal of the *Bangor Daily News* remarked that the interior surface "was an impressive, walnut-like smooth finish." Measuring eighty inches long and a maximum twenty inches wide in the traditional coffin shape, the lid went to the Coast Guard Academy along with disintegrated pieces of the coffin itself.

A mortician from New London, working in cooperation with military officials at the scene and with the Lloyd Leighton Funeral Home in Lubec, said that the coffin contained no artifacts such as buttons or clothing but did contain the larger, recognizable bones. Mortician Alderson estimated that Yeaton stood five feet, ten inches to six feet tall.

Yeaton's remains. *U.S. Coast Guard.*

Legal mandates had slowed the road to reinterment in Connecticut. Commander Heydenreich contacted known descendants of Yeaton and uncovered more. "Without the consent of at least a majority, the court would have to rule against the proposal," wrote Heydenreich in his subsequent account. But by late 1972, he secured unanimous consent of all known descendants.

In an interview, Peter Boyce said that the Coast Guard sought a court order for removal of remains to New London, and if granted, the Coast Guard felt that the body should be placed on federal land as quickly as possible. Boyce added that at the time Lubec was in favor of the move, but Eastport was opposed. Perhaps Lubeckers believed that the New London monument would indeed "draw favorable attention of thousands of people to Lubec." North Lubec was legally within Eastport boundaries when Yeaton bought the property, but when he died Lubec had already separated from Eastport.

Boyce obtained supporting letters from Maine governor Ken Curtis, Senators Margaret Chase Smith and Edmund Muskie and state legislators. Boyce along with Commander Heydenreich, CWO Ken Black, local selectmen and members of the Daughters of the American Revolution (DAR) appeared in formal petition at Superior Court in Machias on March 19, 1973.

The *Bangor Daily News* reported that Justice McCarthy found "that the opponents had no direct connection with the case since they were not heirs of Yeaton nor owners of the gravesite or abutting land."

Temporary Reburial

The burial transit permit, signed by the Lubec town clerk on October 28, 1974, designates the Leighton Funeral Home of Pleasant Street and notes the place of disposition as New London, Connecticut. The document makes no mention of temporary interment at West Quoddy Head Light Station pending transfer to the academy. But at 3:30 p.m., cadets lowered the new coffin into a concrete vault on the lighthouse grounds.

Bob Marston helped dig the temporary grave. West Quoddy was the now retired Coast Guardsman's first duty station in 1956, and he returned here twenty years later after service at Little River, Libby Island, Popham Beach and beyond Maine in New England. Bob helped with maintenance, including painting and paneling the keepers' house for family life. A temporary grave also needed digging.

"We dug the hole way in advance," he said, "myself, Clifford Cheney and a guy named Cook [the light station's engineman, Robert Cook]." Shown the

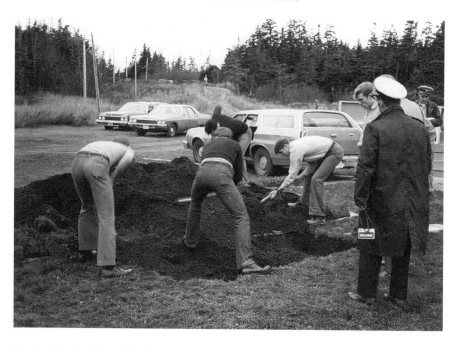

Burying Hopley Yeaton's body at West Quoddy Head Lighthouse. *U.S. Coast Guard.*

photo here, he said, "The farthest car is my '73 Chevy Caprice wagon." Bob Marston soon retired. He likes West Quoddy State Park and the fine view from the parking lot above, but he never went back to the lighthouse because he simply had no reason to. "I look forward, not backward," Marston said.

The Original Grave Site

Looking forward, a November 2, 1974 clipping apparently from the *Bangor Daily News*, datelined Lubec, notes that

> *members of the historical society here met Friday night to draw up an inscription for a monument honoring…Yeaton. Peter Boyce, owner of the property known as the Yeaton farm, homestead, said Friday evening that the Coast Guard officials…asked the society to help design the monument which will be set at the original gravesite…the wording of the monument was still being drawn up at presstime Friday.*

The ultimate legend reads:

> THE REMAINS OF CAPTAIN HOPLEY YEATON WERE MOVED NOV, 1 1974
> TO A MEMORIAL MONUMENT ERECTED AT THE U.S. COAST GUARD
> ACADEMY NEW LONDON, CONNECTICUT HONORING HIM AS FIRST OFFICER
> OF THE U.S. REVENUE MARINE FORERUNNER OF THE UNITED STATES
> COAST GUARD.

The stone lies flat behind the headstone.

Peter Boyce, owner of the southern portion of the Yeaton hundred-acre property, pointed out the headstone. The book *His Window on the World* explains why the DAR installed this tombstone in 1924, replacing the disintegrated original. The headstone, still in place in 2009, reads: "In Memory Of HOPLEY YEATON Esq. who departed this life at Lubec on the 12th day of May 1812 A PATRIOT OF '76."

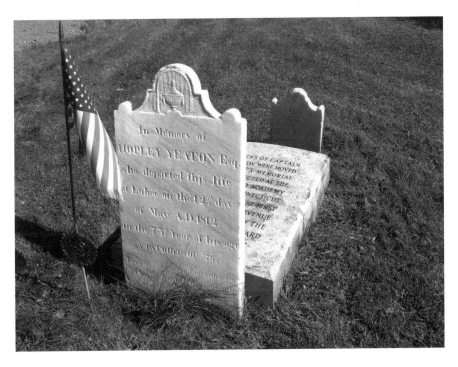

Yeaton's Lubec headstone as it appeared in 2008. *Ronald Pesha.*

To the Coast Guard Academy

The Coast Guard returned on foggy Tuesday, August 19, 1975, disinterring Yeaton's remains for removal to the permanent memorial at the New London Academy. The foghorn sounded all night while Yeaton rested in West Quoddy's brick utility building. Sun broke through the next morning as the small party transported the flag-draped casket back to North Lubec and back to Johnson Bay, where Hopley lived his last years and where the magnificent full-rigged pride of the Coast Guard, the training ship *Eagle*, lay anchored—awaiting the Father of the Coast Guard.

LUBEC'S 1911 CENTENNIAL

Consider changes wrought by the nineteenth century. Specifically, the period from 1811, the founding of Lubec, to 1911, when the town celebrated its centennial.

You traveled overland on horseback or by stage, lodging your jostled bones overnight in the community beds provided by rude inns. You traveled on water in sailing vessels, again devoid of comfort, for the newly developed steamships plied only rivers and routinely exploded and burned.

You ate meat preserved by salt, for refrigeration and canning were yet unknown, and you ate much cornmeal made into corn pone or hominy. You cooked over an open fire, also providing light to supplement expensive candles and smoky wicks floating in dishes of grease. Kerosene lamps? No; kerosene arrived about 1850, too expensive for another decade or more.

You wore handmade clothing, literally "home spun" until 1830. Americans wove more cloth at home than in mills. You lived in crude houses, often fabricated from readily available logs in the wilderness of Maine, for few could afford much hand- or water mill–sawed lumber. Handmade iron nails, indeed any metal products, were a rare blessing.

For communication, cities published newspapers, the daily just gaining a foothold. But almost universal literacy among men above the poor fell to 50 percent among women. Few individuals mailed letters, for delayed delivery (also via horse) remained uncertain. Postage stamps were introduced in 1847.

Your doctor, if you found one, could set bones, stitch wounds and remove bullets (without anesthetics), but little scientific medical practice existed. Physicians still treated disease by purging and bloodletting. Not for another fifty years would Pasteur discover the existence of germs and pathogens, and Lister's discovery of the importance of sterility was further down the road.

A Century Later

By 1911, high-tech transportation by railroad and steamship routinely moved vast numbers of ordinary Americans plus all but local mail. Only the affluent owned cantankerous cars, but people perceived rapid spread. The Wright brothers' airplane encouraged visions of flights across the ocean, even to the moon.

People commonly used the telegraph and the telephone, confidently expecting electrical transmission of pictures by wire or even wirelessly—the wireless telegraph expanded rapidly for ship-to-shore communication, a development made dramatic by the *Titanic* disaster nine months after Lubec's centennial. Electricity lit all public buildings and streets with steady expansion into urban homes.

Clothing, hardware and others vendors sold manufactured goods just as today. Grocers offered packaged and canned goods, lacking only today's ubiquity of frozen "convenience" comestibles.

Medical schools taught scientific practices, making surgery, vaccination and even electrocardiographs routine.

Altered attitudes defined the hundred-year span. Had your 1811 ancestor predicted instant communication, horseless carriages and flight, lockup as a lunatic likely followed. By 1911, ten decades of industrial progress and flowering of invention convinced all but the most dour that anything was possible—the fledgling century was on the cusp of paradise on earth for all.

In some ways 1811–1911 changed life more than the twentieth century. Wired and wireless transfer of intelligence and our trains, planes and cars all developed and matured in sophistication, but we still use the same basic methods of communication and transportation. We buy manufactured clothing and processed food, live and work in high-tech structures and benefit from scientific healthcare and hundreds of other advances. However, this one hundred years also gestated tyrannical hate and destruction to a degree unseen in centuries past. We entered the twenty-first century grave, solemn and lacking in positive expectations.

Lubec in 1911

Lubeckers shared the young century's hope and expectations for flourishing universal peace and prosperity. Prosperity precedes pride, which translates into action, enthusiastically embraced in a centennial celebration and

thoroughly chronicled in the weekly *Lubec Herald*. While newspapers had existed in America since the 1600s, those rugged residents of 1811 could hardly have imagined a local Lubec periodical. The community grew fast, yet a century of technology made possible such a periodical in a community of fewer than 3,500 souls.

Accommodating Guests

The May 31 *Eastport Sentinel* admitted that that city's centennial passed unnoticed, but it noted accelerated planning in Lubec across the bay. "It would not be right if the people of that enterprising town allowed [the event] to pass into history without that recognition."

The *Sentinel* pronounced Lubec "easy to reach," given the Lubec/North Lubec/Campobello/Eastport ferry. Clearly, Lubec anticipated long-distance tourists. The Eastern Steamship Company docked three times per week in summer—Boston to Lubec was 297 miles at $6.25, "meals and staterooms extra."

With water transportation the prevailing means of travel, Lubec erected its greeting arch above Commercial Street leading from the ferry and

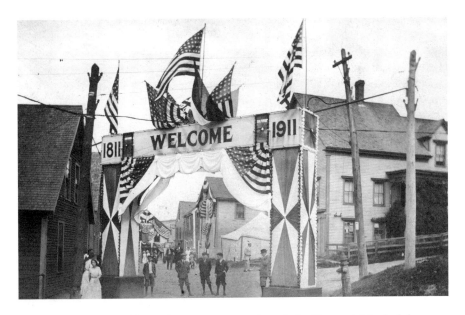

From the steamship and ferry wharves up to town through the Centennial Arch. *Lubec Historical Society.*

67

Eastern Steam Ship Company wharves to Water Street. The town placed a similar arch on Main Street. In the image here, the photographer stood facing Commercial Street looking toward the far corner of Water Street, site of most retail establishments. Pleasant Street enters from the near right, just beyond the fire hydrant.

Bunting proudly enveloped the town, businesses and residences alike. Note the long skirts, still stylish, and the boys in knee knickers. Most of these buildings are no longer extant; a sharp grassy drop-off on the left overlooks the town wharf. Only the large building in the right foreground remains, in fine condition and for sale as of 2009.

Note the cast-concrete base on which the right pedestal stands. This concrete block still exists, its great weight pushed back adjacent to the left side of the fire hydrant.

The Events

On October 5, 1910, the *Lubec Herald* editor called for a centennial celebration as "an epoch in the history of the town…now is a good time to take it up." A step-by-step planning process began the following April under the direction of businessman C.H. Clark. Coverage of the holiday waited for the July 12 newspaper. Handwritten on the microfilm appears "None of July 5, 1911." That date, a Wednesday, would be the normal day of publication for the weekly. Obviously, no issue was published the day after the fourth. Editor Keene was probably exhausted.

By comparison, the Lubec Historical Society called attention to the bicentennial back in 2003, and the town set up a planning committee in 2008.

Among the 1911 planning steps, committee members considered closing Water Street to cars to avoid congestion. Though automobiles were few, sufficient vehicles existed to schedule an automobile parade on Monday the third, preceded by a hill-climbing contest up the steep grade from Flatiron Corner to the churches atop Main Street hill. The July 12 *Herald* reported few entries received—the fast race was won by E.M. Lawrence, and the high-gear low-speed climb was won by sixteen-year-old Carleton, son of Bion Pike. (Licensing of drivers lay a few years in the future.)

Though Lubec's actual 100th birthday was June 21, the centennial weekend began on Sunday, July 2, with events on the third and fourth. At 6:00 a.m. salute of twenty-one guns with "chorus of bells and whistles" opened the Fourth of July in 1911. Scheduled morning events included hundred-yard

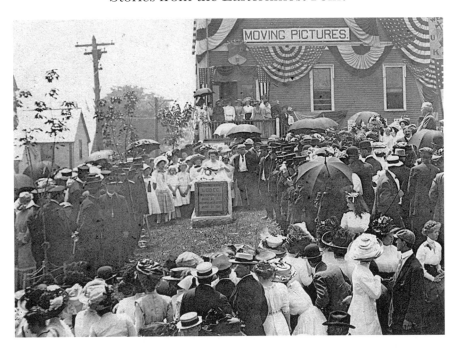

Unveiling the centennial stone. *Lubec Historical Society.*

dashes, a logrolling contest, the inevitable greased pole of the era and an apparently short baseball game between Lubec and Eastport High Schools at 10:00 a.m.—short because all gathered at Monument Lot for speakers Dr. Anton Marquardt of Colby College (Waterville, Maine), formerly of Lübeck University, Germany, and Judge Mahar (Augusta, Maine). Suitably attired schoolchildren scampered into position to form a "living flag, which preceded the unveiling of the new centennial stone."

Monument Lot, a gift to Lubec from town benefactor and sardine mogul Bion Pike, found its Civil War statuary joined by a simple memorial tablet, a dark stone engraved with "Lubec/Incorporated July 21 1811/ Commemorated/June 21 1911." With parasols shading the hot July sun and the bunting-clad Knights of Pythias Hall in the background advertising "Moving Pictures," Evelyn Pike, daughter of Bion and twenty-six days short of her nineteenth birthday, lifted the shroud unveiling the marker.

The centennial tablet remains in 2009, calm and mute, awaiting Lubec's third century commencing in 2011. Lubec is also planning its *bicentennial* celebration for the Fourth of July weekend. In 2011, the fourth falls on a Monday.

Commemorative Memorabilia

The June 21 issue of the *Herald* reports that bronze souvenirs arrived and may be secured from C.H. Clark at twenty-five cents each. Clark Furniture Company was headquarters, executive office and the "repository for relics and ancient documents."

Three styles of memento pins exist, at the low end a lithographed "tin" pinback button in a style still common today. Many Lubeckers bought a dime-size bronze medallion on a stickpin, the more affluent paying twenty-five cents for the larger, more elaborate "Bronze Souvenir Pin" available from C.H. Clark's furniture store and centennial headquarters. Across the top of the medallion was "Centennial of Lubec 1811–1911" above an image of the sun rising over the sea, encircled by "Town of Lubec Incorporated,"

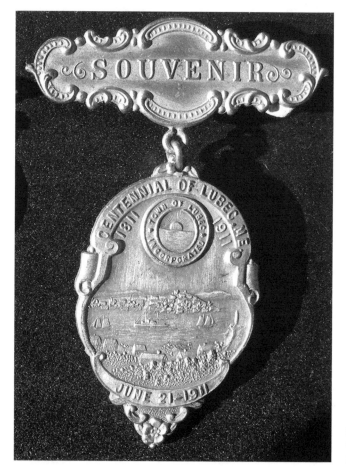

Souvenir pin from the Lubec Historical Society Collection.

reflecting Lubec's easternmost status. The central area shows Lubec village from the traditional vantage point, Campobello Island, showing sailing ships in the Lubec Channel. Across the bottom appears the actual date of the centennial, "July 21, 1911." A handsome keepsake.

The Images

Fortunately, Lubec engaged a professional photographer, A.B. Jessaman from Boston, to document the historic event. Jessaman also photographed many of the floats prepped for the big parade, Eastern Star, the "Torrent" manual fire pumper, Pocahontas and Red Men. A patriotic fraternal organization, the Red Men emulated the Iroquois Confederation's democratic governing body as the Order of Red Men. Later adopting the name Improved Order of Red Men, the Lubec IORM bands became popular around the turn of the century.

Atop the hill and adjacent to the municipal Columbian Hall, with roof visible at the right, Lubec School lavishly exhibited the stars and stripes. The right-hand four-foot portrait clearly portrays Maine's popular statesman, "Plumed Knight" James G. Blaine. Speaker of the U.S. House,

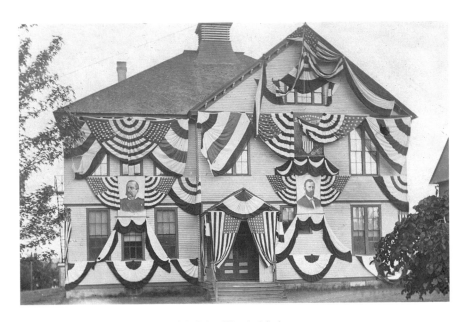

Lubec School honors the centennial. *Lubec Historical Society.*

U.S. senator, twice secretary of state and national Republican leader in the post–Civil War period, Blaine failed only when he faced Democrat Grover Cleveland for the presidency in 1884. The left-hand image in the photo here originally suggested William Howard Taft, then president (R), yet the eyebrows and the receding hairline strongly resemble Frederick W. Plaisted, governor of Maine (D) 1911–13. Surely the town centennial would honor two Maine statesmen.

The German Connection

Back on June 21, the *Lubec Herald* proudly proclaimed that "on the date of this issue the Town of Lubec attains its one hundredth birthday," boasting that the town has grown steadily in size and importance. U.S. census records show a steady *decline* in population from 2,814 in 1850 to 2,069 in 1890. (The census recorded only county populations before 1850.) However 1900 turned around, with 3,003, and 1910 reached 3,363, only eight people short of Lubec's all-time high in 1920. Expansion surely prevailed for the celebration.

"Settled by the French," continued the *Herald*, "but endowed with a German name, the town has always been a cosmopolitan community." That same June 21 issue reported receiving this letter in German, which two high school staffers translated:

> *The Senate of the Town of Lübeck of the Hanseatic League has received with great interest the information that the commonwealth in the new continent across the ocean, which through the similarity of name is so closely bound to our Republic, can at this time look back upon an existence of a hundred years. While the Senate sends to this celebration that is so full of significance, its congratulations and expresses the wish that the town may also enjoy for a long time a prosperous growth, it hereby takes the liberty to send, together with an engraving in wood which shows a picture of our town in the 16th Century, two photographs of Lübeck at the present time; one of which shows a view of St. Peter's Church from St. Mary's, the other a view of the harbor of Lübeck. With the request that you be willing to give these pictures a place in your town hall, we add the expression of our regret that we are not able to send a representative to the Centennial.*
>
> *(Signed) The Senate of the Free Town of Lübeck of the Hanseatic League.*

The gracious gesture from the ancient city of Lübeck, population about eighty-three thousand, twenty-five times the size of little Lubec, Maine, initiated much anticipation here. Excitement expanded throughout the town, soon amply rewarded by the gifted artwork of commanding size:

That our German cousins appreciate being godmother on this side of the ocean is strongly attested by the arrival last week of a huge express package which when opened at the headquarters, proved to contain a magnificent

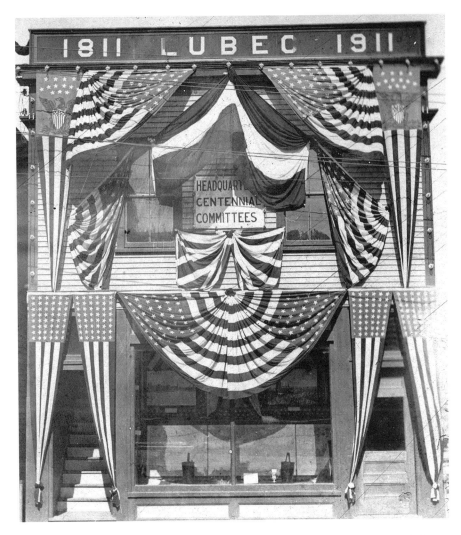

Headquarters displayed the gift of artwork from Lübeck, Germany. *Lubec Historical Society.*

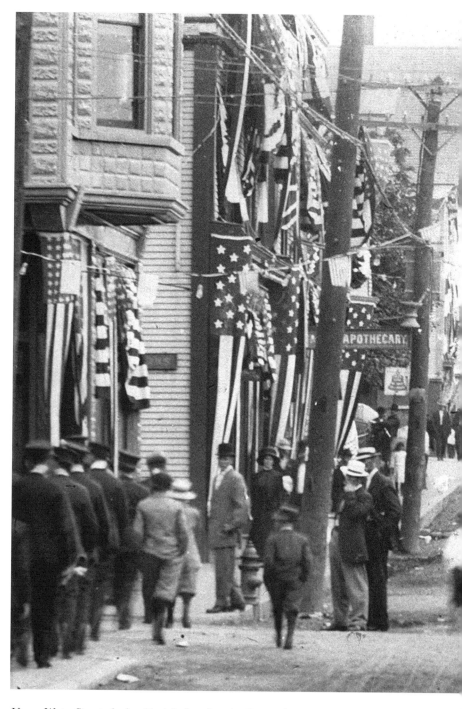

Upper Water Street, the last block before the wharf area, draws a crowd on centennial day. *Lubec Historical Society.*

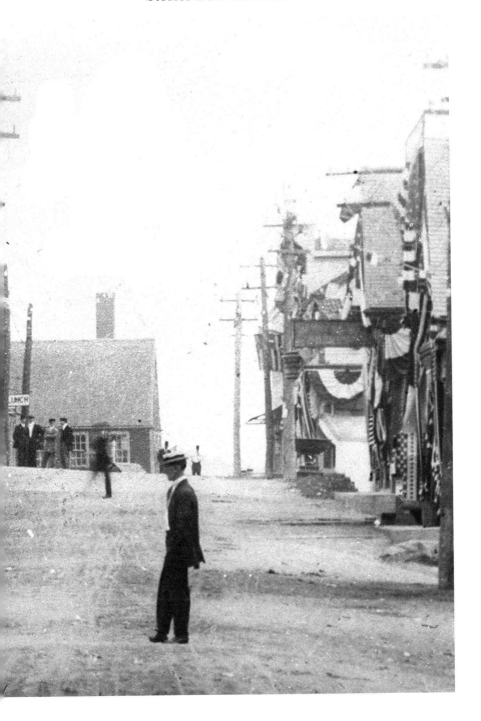

engraving of Lübeck, Germany, in the 16th Century. This engraving, which is eleven feet long by three feet wide is handsomely framed in dark oak and reinforced with brass stays. It shows the ancient town, with its waterfront and cathedrals, its quaint German architecture and sharp-roofed houses, its odd-looking boats and winding streets. Even at that remote period, Lübeck seems to have been no small town. The large engraving is accompanied by two smaller framed pictures, showing views of the town today, excellently done by native photographers and engravers. All three pictures are very valuable, and it is doubtful if they could be purchased from the town at any price. In fact, the town feels highly honored and grateful to its godmother for such an interest as the gift of these articles evinces. Considerable information in German is printed on the three engravings and is attracting the attention of students of that language. Souvenirs of the package in the form of nails, splinters of wood and bits of the lettering are eagerly sought for as relics of our hundred year remembrance from across the sea.

Centennial headquarters promptly exhibited the renderings in its street-front window for all to examine. The extravagant eleven-foot engraving inhabits the window's full width, with the pair of smaller images above, to each side of and partially obscured by the half-circle bunting. A later issue of the *Lubec Herald* muses over the dilemma of permanent display, admitting that "cosmopolitan" Lubec lacked a suitable hall.

Ultimately, the compositions were housed in the new brick edifice erected in 1911 for Lubec Trust and Banking. A letter in the newspaper a quarter century later notes that the art is still there...and there the story ends. Ultimate disposition of the art is not at hand as this book goes to press. Inquiry among older individuals and queries in local newspapers failed to elicit memories of the landscapes.

Photographs as Memories

Photographer Jessaman inscribed on his visual ledger the real center of activity, average people on the streets of Lubec. Looking north on Water Street, the building over the hump housed the Lubec-Campobello Auto Ferry office as demand for such service originated and expanded. To the left, band members await their musical responsibilities. A sign for Mabee Apothecary, a longtime Lubec business later called Mabee Drugstore, appears down the street. Jessaman's images are widely reproduced on photographic postcards,

which frequently exhibit hazy, poor-quality printing, though this image suggests fog, a very real possibility in Lubec even on July 4. More than once fog cancelled fireworks.

These photographs, these memories—this instant of history, frozen in time, indelibly enshrined as images of another human era. How did these individuals differ? How were they like us? How much do we adhere to their hopes for the future?

How much have we really progressed in a century?

THE FUZZY WUZZY
CAT FOOD HOUSE

Much assistance in this chapter came from Bernard Ross.

Known at one period as the Forewinds House, the Cape at 117 Main Street sat far out of town in the nineteenth century.

Initially a seven-room farmhouse, subsequent additions added four rooms. Original construction details reveal adze-cut twelve- by twelve-foot cellar beams and an eight-foot archway with heavy oak sliding doors connecting main rooms. According to Annie Gerrish, owner with husband Leroy for almost forty years at the end of the twentieth century, early residents operated a sort of bed-and-breakfast, taking in overnight "stopovers" and stabling their horses in the property's barn. "Transportation being so much slower then, it was a common practice to take in people (mostly peddlers) and to set a place for them at their table."

The earliest deed registry dates from February 1861, when Oliver Burnham sold the house to a succession of Lubec surnames. In modern times, West Lubec native and Lubec Historical Society elder statesman Bernard Ross while searching back through deeds of previous owners reached a dead end at a property holder named Olive Dixon. "We couldn't find a deed showing where she obtained the property," he said.

Ross decided to research the original owner of all the land along the shore and check on any land lots sold. One possibility popped up: Thomas Burnham, a yeoman woodworker. "There was no transfer of the property from Thomas Burnham to another owner," said Bernard. Then he found an account of the *Quoddy Belle*, a sailing vessel, in an 1899 Lubec publication.

Half a century earlier, in gold rush times, there were three routes to California—overland by prairie schooners, another by steamer via the Isthmus of Panama walking across the Isthmus to another steamer and the last by sailing vessels around Cape Horn.

Flatiron Corner, circa 1895; Forewinds House is visible left of trees. *Lubec Historical Society.*

Later view of Flatiron Corner, circa 1905; Forewinds' double chimney and two gable windows are visible below what appears to be a stack on the horizon.

Thirty-three wealth-hungry Lubec residents selected the latter route, engaging the brigantine *Quoddy Belle* of 160 tons registry to take them to the gold fields. They sailed from Lamson's Wharf (possibly at the site of today's Peacock Co.) on November 27, 1849. Much of Lubec turned out to wave them on their quest for riches. Even the captain and most of the crew were Lubec men. Enoch Fowler was master, Moses H. Pike first mate, Clofus Pike second mate and William Ramsdell steward. According to the original article, they made port at St. Catherine, Brazil, on January 13. On the twenty-third, they continued their voyage, encountering a gale of seventy-two hours'

duration off the mouth of the Rio de la Plata. At the sixty-second degree of south latitude, the course was changed to the west, and they rounded Cape Horn after twenty-one days battling with the elements.

On May 6, 1850, the captain sighted the entrance to San Francisco Bay and the next morning passed under the Golden Gate, 160 days out from Lubec. Eighteen thousand miles in a vessel scarcely large enough for a coaster. "Imagine," said Ross, "all those people on that little vessel for 160 days."

Reports of successful prospecting have not surfaced, but we know one eager Lubecker never arrived in the gold-scented Sierras. The article relates that "Thomas Burnham, one of the passengers, was taken sick soon after leaving the Port of St. Catherine, died on the first of March, and was buried at sea at 137 degrees west longitude just north of the equator." Ross points out a likely error in the account, as that longitude is well out in the Pacific and far from the normal voyage along the coast to San Francisco.

The widow's name was Olive, who inherited the property and later married a man named Dixon. Eventually, heir Olive Burnham Dixon transferred the property. Burnham, by the way, was a son of the Eastport town clerk who accepted the 1810 petition to set Lubec apart from Eastport as a separate town.

Prominent Lubec businessman and selectman John Irving Wilcox acquired the property in 1914, and it remained in that family until September 1949, when it was purchased by Sherman Denbow. As the property abuts the bay, Wilcox built a fish stand down the bank, at which he put up smoked herring. Denbow added a factory and boiler house behind the house near the old fish stand, constructed a warehouse to store the product for shipping and canned cat food under the names "Fuzzy Wuzzy Cat Food" and "Kalico Kat." Fuzzy Wuzzy Cat Food labels bore the legend "Packed by Sherman Denbow Fisheries, Inc., Lubec Maine," while Kalico Kat labels indicated distribution by National Pet Foods, Inc., Marcellus Falls, New York.

Denbow dealt big. On October 9, 1947, the *Lubec Herald* reported that after selling his sardine plant he capitalized a new corporation at $100,000 as Sherman Denbow Fisheries, Inc. In January, the former Tucker Smokehouse that he was remodeling collapsed, but that failed to faze him. A week later, he was the high bidder for a war surplus 110-foot submarine chaser.

Bernard Ross tells how young Sherman refused high school attendance. He attended ninth grade for two years to meet the state requirements for age at which one could leave school. At various times, he was tax collector for Lubec, selectman and first selectman, and he served two terms in the Maine House of Representatives. He later owned several smoked herring

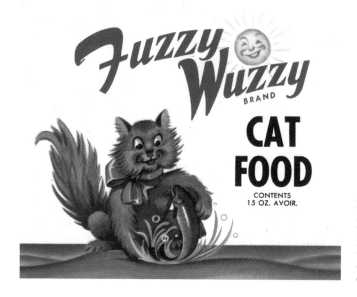

Fuzzy Wuzzy brand cat food label, packed by Sherman Denbow Fisheries, Lubec. *Lubec Historical Society.*

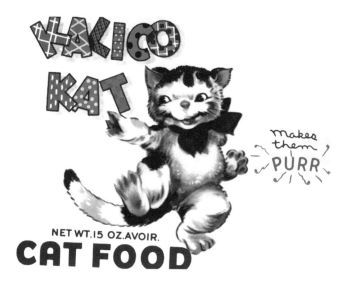

Kalico Kat brand cat food, packed by Sherman Denbow for National Pet Foods of Marcellus Falls, New York. *Lubec Historical Society.*

stands. He remodeled the McCurdy Stand on lower Water Street (beyond the later Campobello Bridge site) into a sardine factory and the Tucker Stand after repair into a sardine factory. A major dealer, Denbow purchased for resale much of the smoked herring production from Grand Manan Island, Canada. Then came the cat food business, and later he raised hens for eggs and broilers. Denbow died on July 15, 1963.

Forewinds House. *Lubec Historical Society.*

Annie and Leroy Gerrish purchased the property and continued the operation of the hen farm until market conditions deteriorated. The Fuzzy Wuzzy Cat Food house remains in 2009, looking little different from the 1940s photo here. The Maine Historic Preservation Commission's identification number for it is #253-0011. Few passing by today, on State Route 189 and Main Street, know of its colorful past. But you do.

A COLORFUL BUNCH

Many Lubec families, some counting back far beyond two hundred years, deserve book chapters. Space limits coverage to one family of many branches, the Pikes. Perhaps someone else will devote a book to all of the long-established ancestries here, which would demand dozens of chapters.

Sailing ships actively traded around the world during the early 1800s. The "Baltic Trade" in naval stores, which dealt with rosin, turpentine, hemp and more, occupied Captain Moses Pike of Massachusetts. He put into port at Lubec about June 1811 and liked what he saw: a port safe for smuggling, with a lone customs agent far from federal authorities in Washington.

Customs duties were a prime provider of income for nascent nations in those days; the U.S. government survived on such funds. However, the War of 1812 at this border region encouraged laconic local officials to look askance at outside intervention. Western world market conditions created volatile fluctuations in fees, easily manipulated by fast ships and forged papers. How fast? Well, Captain Moses knew that duties on Spanish wool cost far less than that from Canadian sheep. He set sail for Spain and returned in twenty-four hours, his hold filled with wool and he holding Spanish papers.

Moses Pike prospered. He moved his Massachusetts wife Sophia Marston to this far-distant land called Lubec about 1816 with their first four children and then sired five more, the youngest Jabez Marston Pike, (1824–1904). Jabez's firstborn sons, Jacob Clark and Bion Moses, sired two Lubec branches of prominent Pikes. From his father Moses, Jabez learned certain the secrets of business well.

Like Scion Like Son

The 1909 *Genealogical and Family History of the State of Maine* in a prudent, guileless manner noted that

> *Jabez' early occupation was fishing and farming latterly butcher and proprietor of a meat market having for many years the only meat market in Lubec. In religion he was connected with First Christian (now Congregational) Church (which papa Moses helped to found in 1816). In Republican politics he filled some of the local offices.*

Much later, Sumner Pike revealed the dastardly details. Penning a 1948 article in the *Saturday Evening Post* magazine, in those days before television an immensely popular national periodical, he told all.

Titled "Grandpa Was a Smuggler," Sumner Pike relates how his grandfather took over the ancient country store started by Moses. "He also inherited part

The old smuggler himself, Jabez Pike. *Lubec Historical Society.*

of the Pike farm, which was a blind for his later smuggling activities." By the Civil War, "There was a fantastically high duty on Canadian wool, so he conceived the idea of running in wool from Campobello and mixing it with his own wool."

Now this Canadian island lies just across Lubec Narrows, dangerous during bore tides but readily rowed even by youngsters raised in coastal regions. Jabez's preteen sons Bion and Jake procured the precious wool on many a foggy night.

Then Jabez heard about the imminent arrival of a government official. "Grandfather wasn't sure whether he was somebody from Agriculture, wanting to know about these miraculous new sheep that yielded 400 pounds of wool per year, or a Treasury man. But he didn't wait to find out."

Not surprisingly, old Jake prospered during the years hiding out in Canada. Again with cooperation of his sons and their adolescent growth of stout muscles, he peddled assorted goods from the old store to the Campobello islanders without the detriment of pesky duties.

"Grandfather got rather tired of being an exile, and when Ulysses S. Grant became President in the spring of '69, a dicker was arranged that enabled him to come back," added Sumner Pike. "It was a consent order, whereby grandfather made full confession…[and] stated that he repented his sins and wouldn't do it anymore." Whatever really happened, he continued to prosper.

Jacob and Bion Pike

His sons, strong from all that rowing and wise in business acumen, turned to more legitimate Lubec affairs.

Jacob Clark Pike (1854–1928) slipped away to a ship as an adolescent second mate, rose to captain and came home after seventeen years. Granddaughter Penney wrote that "grandfather was said to have jumped out of the school house window at age 14 and gone to sea." Nina Bohlen (stepdaughter of Carleton Pike, who married Margaret Curtis Bohlen), added, "I have always heard that he jumped out the window because of lye soap in his pocket, burning through his pants." Anne Pike Rugh continued, "His mother Diana had a home soap business going, and Jacob delivered the bars before school, if there was time, which apparently there wasn't. His father had threatened a thrashing if his teacher sent home another bad report, so…off to sea he went."

He returned to Lubec still a young man and captain of his own ship. Penney Pike Lemon wrote that "he took the first load of ice to the island of Barbados; I believe he spoke fluent Spanish." Settling into the sardine business, he was soon

Ferry Landing, Lubec, with connections to North Lubec, Eastport and Campobello. *Lubec Historical Society.*

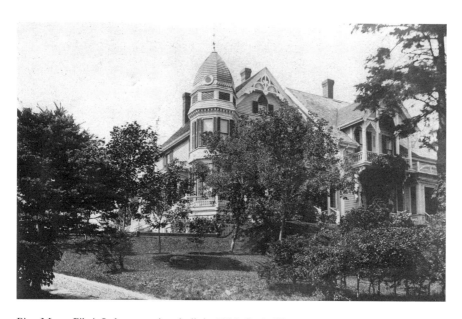

Bion Moses Pike's Lubec mansion, built in 1894. *Davis Pike.*

a solidly established stockholder. He was a member of the Maine legislature in 1901 and 1903 and served as chairman of the board of selectmen of Lubec, and President Theodore Roosevelt appointed him customs collector of the ports of Eastport and Lubec. A substantial citizen and family man, indeed.

"Childhood among the Pikes was a somewhat harsh affair, going back several generations, I gather," wrote Anne Pike Rugh to the author. "I did not know my grandfather, Jacob, who died at age 74, but people seemed to remember him as kindly, and my father worshipped him. His diaries reveal a sentimental man…In general, however, emotions were to be kept buttoned up, and the family was not demonstratively loving."

Brother Bion Moses Pike (1856–1922) also went to sea and in four years rose to the rank of mate, making a number of foreign voyages. He returned to Lubec and began operating a ferry service circumnavigating Lubec, North Lubec, Eastport and Campobello Island. In 1882, a steamboat took the place of his sailing vessels. The 1912 *Maine Register* lists Pike as sole owner and manager of Passamaquoddy Steam Ferry Co. and also a dealer in salt and a ticket agent for the Maine Central Railroad, accessible via the Sunrise County Railroad at Eastport to which Pike provided ferry service.

Bion Pike built a Victorian mansion in 1894, still a Lubec landmark in the Pike family. Donating Monument Lot to the town, he funded the Civil War

Bion Moses Pike's daughter, Evelyn, throws the switch at the power plant. *Davis Pike.*

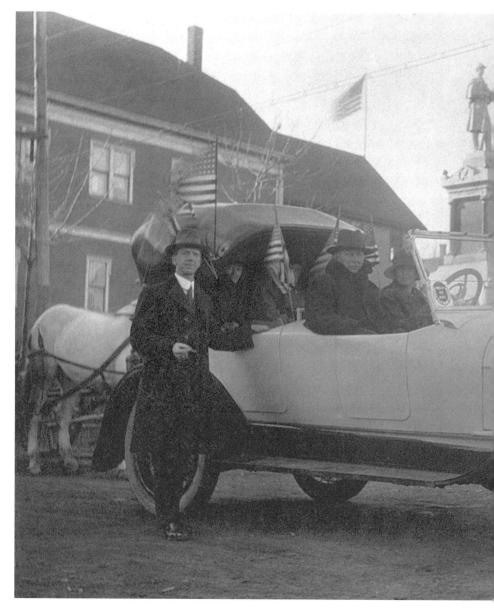

Owen Magnetic auto on Pleasant Street at Monument Lot. *Davis Pike.*

statue joined in 1911 by the Lubec centennial granite marker and in later times by appropriate additional military memorials.

Firstborn Evelyn became the princess of Bion's family. She christened the electrical generator, unveiled the 1911 centennial stone and

drove her father's Owen Magnetic automobile. A high-end brand of luxury automobiles manufactured between 1915 and 1922 with an "electromagnetic transmission," 1916 models ranged from $3,000 to $6,000. The gasoline engine turned a generator to power an electric motor driving the wheels—something of an early hybrid but lacking a battery bank.

Carleton and Alger

Carleton, son of Bion, and Alger, son of Jacob, both served during World War I. Bowdoin class of 1917, Carleton managed to leave six months early for ambulance driving in France. He then enlisted in naval aviation and racked up several hundred hours of flying time as instructor, patrol and experimental pilot through 1918. Afterward both joined Sumner in the New York and Boston financial worlds. Though in Lubec on November, 1921, at his father's death, a brief period later as clerk of the Senate Naval Affairs Committee in Washington preceded periods as treasurer of Seacoast Canning in Lubec and other financial activities in New York City. At the outbreak of World War II, Carleton informed the navy of preparation for "immediate mobilization" and returned in 1945 as full commander.

Alger retired from Wall Street business at age thirty-five. As with so many Pikes, love of Lubec compelled a return. Back home, Alger nurtured his family.

Lieutenant Commander Carleton Pike in World War II. *Lubec Historical Society.*

Penney Pike Lemon wrote about the excellent quality of his fathering. "He never raised his voice and I never heard a word spoken in anger or a mean remark about another person." Stan Lemon describes him as "a thoughtful, well read, generous man, and one who held people to high standards." He was a man of his time, so most of the child care was left to the women of the household. But he often took Penney with him to the farm, allowing the unrestricted dreaming, contemplative reveries and boundless exploration so essential for children. He brought orphaned lambs and goslings to Penney in the spring, once even a young crow that had fallen from its nest.

When Alger returned to Maine, he served two terms in the Maine legislature. In Lubec, he specialized in building heart-shaped weirs along the outer coast, as these herring-catch pens formed the heart of Lubec's sardine canning industry. At one time he was the largest coastal landowner in eastern Maine, due to land that he bought to secure his weir/fishing rights. Called to Washington during World War II, he took charge of fisheries as a "dollar a year" man.

Clearly the Pikes participated in many of Lubec's phases and had busy, glittering lives. "Mrs. and Mrs. John Roosevelt lunched Wednesday with Mr. and Mrs. Carleton Pike at their Main Street home," wrote Lubec's newspaper. John was Eleanor and Franklin's youngest son. "The Roosevelts frequently visited at the Pike home in Lubec and at their winter residence in Brookline, Massachusetts. Mr. and Mrs. Pike were guests at their wedding."

As Mainers, Carleton and Alger enjoyed hunting, going out for woodcock, partridge (ruffed grouse) and, of course, deer. Carleton's daughter, Diana, relates an incident from the fall of 1948 or 1949. While deer hunting, they came across a large bear, hardly uncommon in rural Maine. One of them shot it, but a little later they came across three small cubs. They realized that they had killed the mother and deliberated on what should be done next. They decided that it was best to kill them quickly rather than have them try to feed and care for themselves. "The result was this photograph, which horrified me as a child, and a freezer full of bear meat which replaced the usual ice cream," said Diana.

A skilled, knowledgeable and sensitive hunter, Alger engaged his avocation like a true Mainer, surrounding himself with the appurtenances of his passion. In 1932, he acquired a fine set of decoys from legendary Maine carver Gus Wilson, whose work is avidly sought by collectors.

Daughter Penney wrote of her sole adventure taken hunting, shooting ducks from a boat. "I may have cried when one hit the water still alive and struggling. I guess I was not considered good hunting partner material at that point." Hustled home, she rejoined the "womenfolk."

Cousins Carleton and Alger Pike with unexpected results from a hunting outing. *Penney Pike Collection.*

In addition to hunting and fishing, Alger loved his farm. Nina Bohlen says that he grew "amazing vegetables" and developed new varieties with biologist brother Rad.

Continuing the Pike Sardine Tradition

Marjorie, Jacob Pike's only daughter, linked with another Lubec seafood processing family when she married George McCurdy. George received training as a radio man during World War I and planned to pursue that line of work in New York until his father called him home to help with the business. McCurdy owned and operated the Columbian Packing Co., which processed and packaged smoked herring and supplied coal that came to Lubec by sailing ship and oil for home heating. A small store, now home of the Lubec Historical Society, sold food and household products.

The fourth child of Jacob was Moses Bernard (1897–1989), who earned an electrical engineering degree from the Massachusetts Institute of Technology (MIT) in 1920. According to daughter Anne Pike Rugh, after graduation Moses and Alger, who attended Bowdoin, rowed their father around, fishing a good deal. Moses functioned as chief engineer to hydroelectric expert

Dexter Cooper during preparation for the Passamaquoddy Tidal Power Project starting in the 1920s. Moses, who oversaw the building of Quoddy Village (the town for construction workers), stayed with the Passamaquoddy project until it was finally killed by Congress. (See more details in the Sumner Pike section.) Then he went into the sardine business like his father Jacob.

From 1937 to 1979, he ran Holmes Packing Corp. in Eastport. A sixty-nine-year member of the Stuart-Green Post No. 65, American Legion of Lubec, he also served as longtime Lubec town meeting moderator.

"Maybe I *should* know about the ownership structure of Holmes, but I don't," said daughter Anne Pike Rugh. "One of the challenges here is that women were pretty well restricted to matters involving the home," she said, and therefore they were not privy to business affairs. When "Mose" decided to retire in 1979, at the age of eighty-two, from the sardine business that he managed for forty-two years and owned outright after partners' deaths, Anne's mother, Laura (Sleight), said to her, "Well, we always thought you would take it over." Anne pointed out that training for that should have started a lot earlier in what was exclusively a man's world. Anne said that she recognized that the business was a more fun world. "I just couldn't figure out how to break into it."

Anne continued, "I have tried to bring in the distaff side of the family because they have been so heavily overlooked." She pointed out that Sumner failed to even mention his sister Marjorie in the *Saturday Evening Post* article. "He laughed it off later as the only criticism he received."

"The relationships among the siblings fascinated me, however. It was a remarkable mix of competition and loyalty. Hard feelings arose, but the clan concept always won out. A buttoned lip was the rule."

At any rate, Anne felt little eagerness to enter family fortunes, whose nuclei lay in the overarching trades of Lubec. Sardine processing and canning during the Second World War peaked in quantity about 1950 but had already begun suffering losses. A quarter century later, Sumner Pike explained, "We had an artificial boost during the war." The British War Office commandeered practically all of the British trawlers for minesweeping and other essential purposes. Meanwhile, the government required massive shipments of sardines that could stand a little wetting down, which delayed market contraction. "In '48 or '49 we had three or four pretty hard years when the market was shrinking and the production kept too large," Pike said. During the years 1946–50, losses were about $4 million.

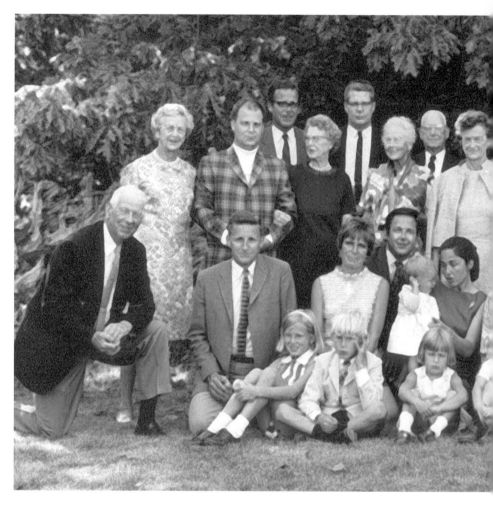

Family photo at Hinckley Point Club, circa 1969. *Davis Pike Collection.*

Family Photo

The photograph here dates from about 1969, taken at the Hinckley Point Club, a popular venue for weddings and similar events along with regular networking by sardine plant owners. "A wonderful view of Cobscook Bay," said Davis Pike. "Fletcher Downes was a great chef, a legend."

Left to right, standing: Penny Greenough, Jake Pike, Robert Harding, Mame Lawrence, Charles Russ, Evelyn Pike Alden, George McCurdy, Laura Sleight Pike, Moses Lawrence, Sumner Tucker Pike, Marjorie Pike McCurdy, John McCurdy, Doris Pike White, Moses Bernard Pike, Ann

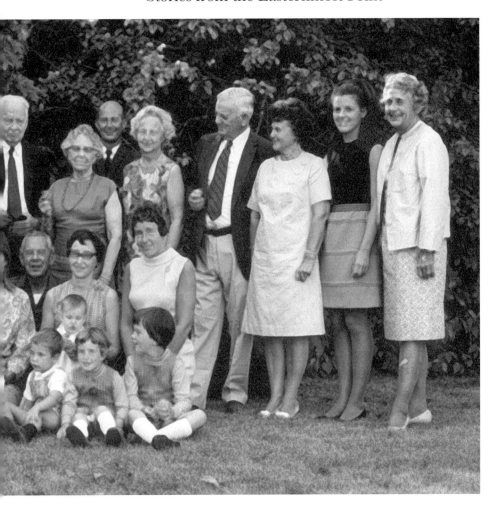

Crane Pike, Anne Williams (friend of Jake at time of photo) and Margaret Curtis Pike.

Left to right, kneeling: Alger Pike (kneeling), Edwin U.C. Bohlen (Buff), Janet Bohlen, Davis Pike, Diana Pike Harding, Nina Bohlen, Rad Pike, Diana McCurdy Russ and Suzanne Pike McCurdy.

Left to right, sitting: three Bohlen children (Nina, Curtis and Julie), Harding baby Alexandra, three Russ children (Michael, Stephen and Marjorie), Suzanne and Elizabeth McCurdy.

Sumner Pike

"Lubec Man to Direct Commission's Work On Production Of H-Bomb" read the headline in the *Bangor Daily News*. "President Truman today chose Sumner T. Pike, a Lubec Republican, as acting chairman of the Atomic Energy Commission." Pending appointment of a successor to David Lilienthal, the first chairman, Pike was obvious choice as last of the original five-man commission.

According to *Time* magazine, the committee's decision preceded the hearing, "leaving Pike sitting in silence without asking him a single question." When he departed, Truman's subsequent nomination was voted down five to four. "One guess on the turndown was that Pike had piqued the Senators in a speech last summer when he suggested that political patronage sometimes influenced their dealings with the AEC." Leave it to a Mainer to speak his mind.

Pike commenced government service as a "dollar-a-year" advisor to Secretary of Commerce Harry Hopkins in 1939, and shortly thereafter he was appointed a member of the Securities and Exchange Commission.

Years later, the *New York Times* obituary said that "his appointment to the S.E C. was looked upon with some uneasiness…however the doubts in Wall Street were allayed by his earlier work…serving chiefly in Philadelphia to protect investors and the public."

Sumner had earned a reputation for surpassing brilliance with abundant academic gifts—"So much so that his teachers didn't quite know how to deal with it," wrote Penney Pike Lemon. Anne Pike Rugh said that Sumner did not drive a car. His mind would wander, and he'd leave the road. After graduating from Maine's Bowdoin College, he tried Texas petroleum, served briefly in World War I and then returned. The 1976 obituary in the *New York Times* provided details. "A skilled petroleum geologist, Mr. Pike prospected for oil and found it, becoming a vice-president of two concerns." In 1922, he turned to Wall Street as assistant to the president of a firm involved in trade with Central and South America. He added insurance in 1924 as secretary of the Continental Insurance Company. This was followed by a post in 1928 with a Wall Street investment house.

By his own account, Pike did well. "In 1938, I thought I'd retire." But he made a positive impression at the Commerce Department, and President Roosevelt needed a Republican for the SEC (the law limits the five-member board to three maximum from one party).

He served six years. "I am getting stale on this job and it is time for me to quit," he wrote to President Truman. Back in Lubec, enjoying the bucolic

pleasure and little pressure, Truman called. The president needed another member for the new Atomic Energy Commission. Sumner said yes. "You're the kind of fellow I like to do business with!" responded Truman according to Pike. "When you quit, you quit in one sentence, and when you take a job, you take it in one word."

If not always a man of a single word, like any down east Mainer he made his assertions manifest. "This town is a wonderful place to live but a very poor place to make a living," he said on a recorded interview from 1974. Asked how to redevelop Lubec and the region without compromising natural assets, he insisted that developers only see two things. One is to come where the raw material exists. Maine grows timber, which means the still viable but clearly shrinking paper industry. The other is tourism, "which to my mind is a last resort. It's highly seasonal, and it converts your local people into servants of a kind." He enumerated several seacoast communities that encourage tourism. Industrial development lacks any promise, because the Lubec region is not within driving distance of Boston. Pike closed saying, "I'm afraid this technology and technocracy has taken quite a bite out of us."

Despite careers involving many locations and peripatetic global gallivanting, Sumner and brother Rad always claimed Lubec as home. In that 1974 interview, Sumner said that for all the years he was away from Lubec he felt like he was camping out. "I adjusted somewhat but I never pulled my roots up from here." He placed effort toward getting home a few weeks each year or whenever possible. "This was always home to me."

Sumner expressed generosity to the town. He often matched fundraising efforts dollar for dollar, especially for the library and the 1955 gymnasium fund drive.

By the 1970s, "Sumner may not venture far from the old homestead," wrote the *Bangor Daily News* at the time, explaining the living room gatherings for cocktails at five o'clock by whomever among the large family were currently home in Lubec. "Sumner doesn't indulge any more but he enjoys the fringe benefits."

Diana Pike Harding expanded the old newspaper story in personal correspondence with this author. "Many of their friends would come to Lubec and be part of the 5 o'clock drinks hour," she wrote. It seems that one with a whimsical sense of humor printed stationery headed "Lubec Oceanographic Society," and in small print beneath it "For the study of the ocean and other liquids. Office Hours 5–6 PM." The story goes that other oceanographic societies, seeing the stationery, wrote and asked to exchange reprints of their publications.

Davis Pike added details. Sumner was the only nonoceanographer elected to the National Oceanographic Board (now merged into NOAA, the National Oceanic and Atmospheric Administration). That is why everyone thought that the Lubec "Oceanographic" Society actually existed. "All the top oceanographers in the U.S. visited Sumner one time or another, as they held meetings at Roosevelt Park under the LOS banner." Sumner said that the Russians even came sniffing around to find this secret Lubec research facility.

In earlier years, the concept of Quoddy Head State Park was conceived at the 5:00 p.m. cocktail hour at Sumner and Rad's 2 Church Street house. Concern for the natural surroundings of Lubec and its environment engaged both Sumner and brother Radcliffe, known as Rad. Sumner and Rad never sought wives. Penney Pike Lemon said, "They were both wonderful uncles and very present in the lives of their nieces, nephews and cousins."

In a 1975 newspaper interview, a reporter asked Sumner about harnessing the remarkable tides of Passamaquoddy Bay, off the Bay of Fundy, for

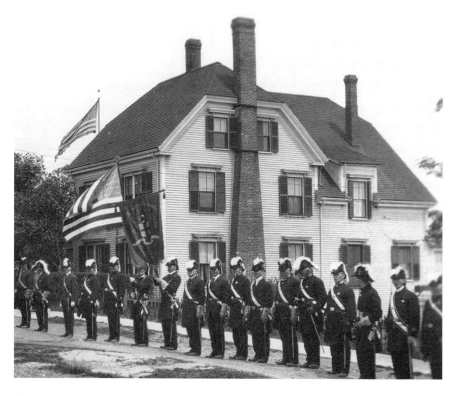

House built by Jacob Clark Pike, later home to Sumner and Rad Pike. The event details are unknown. *Lubec Historical Society.*

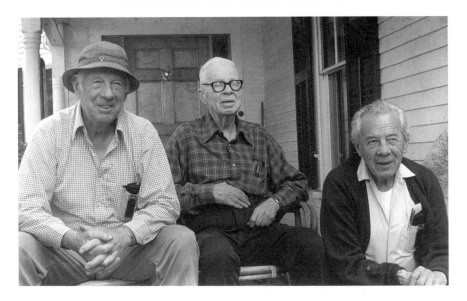

Alger, Sumner and Rad Pike on the 2 Church Street porch in Lubec. *Pike family.*

power. Long planned, Passamaquoddy Tidal Power development actually began physical construction in 1935 under the aegis of the U.S. Army Corps of Engineers, backed by the enthusiasm of President Franklin Roosevelt. Promising cheap electrical power and much employment in the Depression years, construction of smaller dams commenced. Within two years, funding fell to half and then to nothing, due to a hostile Congress in the spring of 1938. The one-thousand-worker company town called Quoddy Village shut down, and the project disbanded.

Thirty-seven years later, Sumner Pike said, "We ought to keep it alive, but, no, I doubt if it will ever be built." He added, presciently for 1975, "With the cost of oil as high as it is, that helps the benefit-cost ratio of the project. Of course rising fuel prices increase construction costs. And in this international border region the impact on the fisheries would impact Canada." Ecological and environmental factors were not addressed, hardly even envisioned, during the Great Depression, except by Sumner and his biologist brother Rad.

Rad Pike

In his book about Campobello, Stephen O. Muskie quoted Rad Pike: "Some people say, 'The best people left Lubec a long time ago.' Others say, 'No, the

best people stayed.'" Muskie continued, "Rad was certainly one of the best and...he stayed."

"He is the ranking authority on the flora and fauna of Washington County [Maine] and nearby Campobello Island," according to the Portland *Sunday Press Telegram* in 1975. As Sumner Pike advocated for the Lubec-Campobello bridge (see fourth chapter), both he and brother Rad immersed themselves in development of the Roosevelt International Park.

"If you want to relive the outdoor life of young FDR and his family, go with Rad on a walk or travel through the wooded paths and drives...the duck ponds and the bogs and fog forests are Rad's domain. He can explain the lichens on the bark of the spruce firs and he knows where there is a hemlock tucked in among the other trees," a rare phenomenon.

Not rare is the ubiquitous fog of this North Atlantic realm, which Rad mused permeates the forest "like a Japanese silk screen." As park naturalist, he designed foot trails through the Campobello forest to create a sense of isolation. Hikers feel alone even though hundreds of others share the paths. "You need trails that stimulate you along the way and make you think. I hope we can create something that will attract students who want to observe the changes in the woods." And he began just that.

Rad held a PhD in plant science with a long career in the Botany and Horticulture Departments at the University of New Hampshire. He left a long list of scientific papers, but the following account originated with Diana Pike Harding.

Rad Pike and the Gasless Bean

Legend relates that Joseph Clark, who in 1788 was the first nonnative child born in Lubec, received some curiously colored beans popular among the Algonquins or Passamaquoddy. Some sources suggest that early colonists introduced the species from Germany to Canada's Prince Edward Island and that the speckled maroon-and-white pattern derives from Biblical Jacob's cows (Genesis 30:32).

As a biologist and a gourmet, Rad felt dissatisfied with the poor yield—few pods with few beans per plant—of the plants that were popular in Maine and the Pike family for baking. According to the unpublished narrative by Diana Harding, "He decided to try crossing it with the black Mexican bean, which was known to have a high yield. It flourished in the high altitudes of Mexico so is ideal for the cool climate of eastern Maine."

Stories from the Easternmost Point

Rad crossed the species in a University of New Hampshire greenhouse, where he taught and conducted research. The day before each bean flower matured, Rad partially dissected and removed the stamen. When the stigma became receptive, pollen was applied from the flower of another plant. The result of this painstaking process was an F1 generation of fifteen beans, which were planted in Lubec by Radcliffe's brother, Alger. They produced an F2 generation of six hundred beans, no two of which were alike.

The following year all six hundred were planted, and at harvest time the pods from each plant were placed in separate bags. Sumner spent the winter shelling, sorting, weighing and labeling them with the yield information. The F2 beans varied widely in color, weight and yield, but the Pike brothers chose the one that looked most like the original Jacob's cattle bean and was most productive in number and weight. By chance, the yield of the plant they had selected was almost completely uniform. By the F4 generation, the bean had stabilized, and the Pike family began enjoying them at the dinner table and distributing them to friends. It turned out that an added benefit of the new hybrid was that it did not cause gastric distress in its consumers.

The local tradition of baked beans led the State University's Maine Folklife Center to insist that "while Boston is known as bean-town, only in Maine can you ever really get to know beans." It's a topic for newspaper writers as well as chefs.

Soon a Maine journalist, who had gotten wind of the story, published the discovery in a local paper, offering a packet of beans to anyone who wrote in. The article was picked up and reproduced by at least one news service, and before long nine thousand replies had poured in. The University of New Hampshire…had to add an extra secretary just to give away the gasless beans, together with directions for planting and cooking them.

Since then, canneries in Maine and Michigan have tried to market the improved Jacob's cattle bean, but its skin has proven too tender to withstand the canning process. It has also been found susceptible to disease when raised in hot climates. But recipients of the bean who live in cooler areas have sent countless letters of gratitude to Radcliffe Pike and his brothers.

Assorted tests followed at the University to determine suitability for introduction as seed. The initial report showed that this variety is highly susceptible to common bean mosaic which limits its chance for survival as a named variety.

Times have changed since Diana Harding penned this account in the late 1970s. One Internet source, Abundant Life Seeds, offers the hybrid but errs

in the credit. "This is a cross between the original Jacob's Cattle bean and a black turtle bean by Sumner Pike of Lubec, Maine." Sorry, Rad.

Back then, though, the anonymous author felt that "the gas crisis will persist except to Lubec where the traditional Saturday night pot of beans will be gasless."

As Anne Pike Rugh wrote to this author, "God knows the Pikes were a colorful bunch."

DEATH OF A HIGH SCHOOL

Written with much assistance by interviewers Seth Doherty, Emma Page, Austin Serrato, Robert Wallace and Stephanie Wright, then fifth graders at Lubec Elementary School, who selected this subject for the book.

The nineteenth-century path to universal formal education in the United States differed from other western nations. Americans considered knowledge essential to social progress and competition with older, more established nations and not merely a job ticket or status requirement. We believed in equivalent education for all and, perhaps most significantly, under local rather than federal oversight. Communities felt a lofty and noble civic calling to hire a "school marm," with the injunction to "go teach the young 'uns."

When Maine became a state in 1820, 236 towns had elementary schools supported by public taxation. The citizens of Lubec had appropriated $800 and built its first schoolhouse in 1817 atop the hill that would be the site of elementary education until 1950. The building that burned in 1913 was built in 1896, "pupils assigned to separate floors according to scholarship," wrote the *Lubec Herald* in 1927. Six graduates that year included still-familiar Lubec surnames such as Mame S. Bennet, Etta Trecartin and Lou Peacock. No students graduated in 1897, but 1898 generated another class of six.

The Day Before Thanksgiving Fire

Fire, kindled by volatile chemicals, destroyed the Lubec school on November 26, 1913. According to the newspaper account, Principal Granville Prock found a loosely stopped bottle of sodium or potassium that exploded, burning his face and eyes. He returned from Dr. Bennet's office, and while he was in class later, the fire alarm sounded. With fire discovered in the lab,

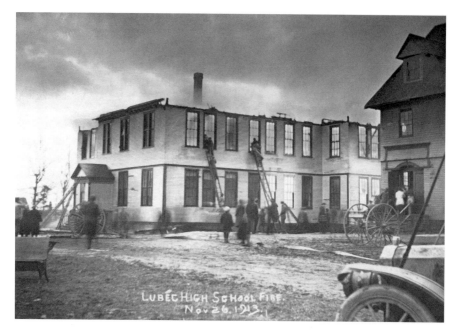

The school fire, November 26, 1913. *Lubec Historical Society.*

well over five hundred students evacuated in an orderly manner. (The 1914 superintendent's report states enrollment at 564, plus thirteen rural schools in the town of Lubec with about 1,345 pupils. With a total population of about 3,365, clearly young adults with large families predominated in Lubec.)

The town's old hand pumper augmented with more modern facilities finally quelled the fire by 8:00 p.m. No one was injured.

A Separate High School

Rebuilding was promptly planned, but early twentieth-century burgeoning of "higher education" dictated a separate high school. "The town voted at its annual town meeting in 1914, to purchase a suitable lot and erect a building adapted to the growing needs of our students," wrote the first ever high school yearbook in June 1916. Data from 1910 indicate that only about 15 percent of American youth graduated from high school, rising to 50 percent by 1940. While these averages were undoubtedly lower in rural regions, Lubec coveted a separate high school for its young people, who were "becoming more interested and ambitious each year to get this higher education."

Four large classrooms on the main floor were planned so as to allow teachers rather than students to move at each period. Steam heat, electric lights, cypress trim and hardwood floors on the main and upper levels marked the most modern of school buildings. The concrete-floored basement provided two labs and two lavatories plus the coal and boiler rooms. The structure was well supplied with ventilators. "We trust that a complete telephone system will be installed in the near future," wrote that first yearbook, the *Quoddy Light*, "as well as fire alarm bells and gongs in the corridors."

The new building began service in 1915, generating repairs and upgrades two decades later, yet it continued service through the graduating class of 1977. Sixty-two years in a frame building!

The first class to graduate from the new structure also issued the initial high school yearbook, *Quoddy Light*, named for Lubec's preeminent Quoddy Head Lighthouse. It was a wooden structure built in the "colonial style," and the town selected yellow paint with white trimmings of cypress lumber. The yellow shade remained until the school's end. According to that proud first yearbook, "The main entrances faces [*sic*] the south." Those entrances held significance. Miriam Kelley, a student during the early forties, said that "in the old high school boys went into one door and girls into the other. I don't know why. We didn't ask questions." The questions would come later.

The New Building

A decade into the twentieth century, electric lighting fully penetrated businesses and public buildings, though 90 percent of rural America remained dark for another twenty-five years. Lubeckers of 1915 wanted an up-to-date high school. "Every room is heated by steam, lighted by electricity, and well supplied with ventilators," said the first yearbook. However, construction standards in 1915 did not specify insulation, and uncaulked fissures abounded. "Those radiators were hot in the winter," said Patsy Kelley, class of 1959, "but wind whistled around the edges of those very tall, very leaky windows, blew curtains inward, and deposited a fine humid mist on everyone in the classroom." The rear of the building faced the seawaters of the bay, and coastal areas are notorious for bitter winds. The English classroom was in the back, and the winter winds "would come around the windows and nearly blow you down," added Miriam Kelley, class of 1945.

By the early sixties, the steam heating system was aging. Shelley Farmer added her comments: "The old building was huge, and very cold. You can't imagine how cold that building was in the winter. I don't think it had any

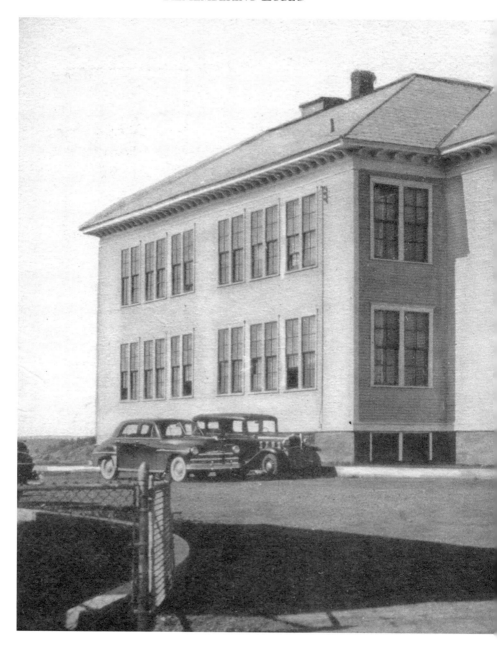

The new 1915 High School on Main Street. *Lubec Historical Society.*

insulation." She told about the single glass windows, requiring mounting of separate tall and cumbersome wood-framed storm windows laboriously installed as each winter approached.

"The furnace broke down a lot," said John McGonigal, class of 1962. "We had a janitor who *lived* with the furnace, Coochie Case. He taught me how to pole vault." added McGonigal. But even athletic Coochie couldn't cure a cantankerous cooker. Often students found themselves sent home on especially cold winter weekdays. Another former student who prefers anonymity said that fine snow sifted down through the ceiling and that the water froze.

Construction inadequacies surfaced early. After it was built, reinforcement became necessary. "They had to put girders between all the windows because walls started to bulge," said John McGonigal. The 1936 yearbook more or less documented renovations in a student editorial. "The class of nineteen thirty-six will be graduated from a building, no longer new, but strengthened and completely renovated during the past year...Substantial posts have given added security; top heavy gables have been removed from the roof which has been given a new fire proof covering."

Academics

The high school added home economics in 1948. The first year included child care, nutrition, grooming and personal appearance. Shelley Farmer, class of 1970, said that "Home Economics, which I really enjoyed, taught me a lot." *Quoddy Light* photos of 1949 show older students operating four sewing machines, including a nonelectric treadle-powered unit, and at electric cookstoves of the time—being of their time, these were restricted to girls.

By 1927, Lubec High status reached "Class A." According to the *Lubec Herald*, any college in New England accepted graduates with an average of eighty-five or better without examination. Scholarship remained high as the diploma format appears familiar. In early 2009, a New York City resident found the example here discarded in a refuse bin. Inquiry located a Manhattan telephone listing for Wendell Cumberland, which proved disconnected. Assumption suggests death, possibly descendants clearing out his belongings. Now preserved in the Lubec Historical Society collection, in another century the diploma may appear curious and quaint. Do save examples of history.

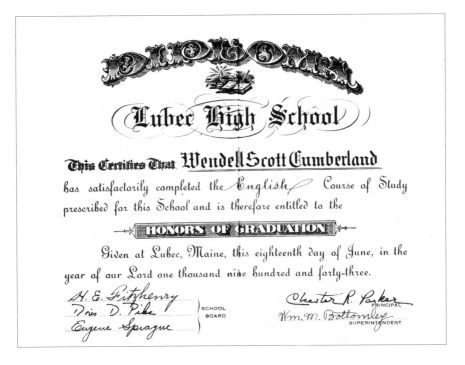

A 1943 diploma. *Lubec Historical Society.*

The Two Front Entrances

Initially, Mr. McGonigal did not recall the practice, but other interviewees said that girls traditionally entered the left door and boys the right. "It was a rule," said Miriam Kelley. Main doors led to a landing, up to the main-floor classrooms and down to the bathrooms. A door led out of each bathroom to the basement classrooms. Oddly, passing through the girls' and boys' rooms seemed the usual pathway to the science room (biology and chemistry) on the left and home economics to the right. McGonigal, prompted by his wife Sharon, remembered the practice. "I entered the right-hand door because it was closer from home."

Where Were the Cafeteria and Gym?

The old building provided neither. Miriam Kelley said that for lunch she went to her aunt's house on Pleasant Street—a fair distance, but then she walked four miles from the farm every day. "If you didn't have any place

to go you could buy a box lunch or bring lunch in a paper bag " That was the forties, but Julie Keene, who graduated with the final class in 1977, corroborated. "We'd buy food to take for lunch, or bring it from home." Julie lived close enough to go home for lunch.

No gym class or physical education existed, said Miriam Kelley, who attended during the World War II years in a class that started with fifty-six and graduated thirteen because of military attrition. "You got your physical education working on the farm. And 'hoofing it' four miles each way to and from school."

The new elementary school, completed in 1950, added a modern gym in 1955. Just a few hundred yards from the high school, proximity permitted routine use. "Basketball became the big sport," said John McGonigal, who also mentioned baseball, track and cross-country. "One year we went to State at Bangor," where Lubec found itself competing against much larger schools.

Shelley Farmer described a fencing team, a rifle team and a glee club. "We had a National Honor Society [for which] you had to have an A average." Shelley also told of the fine band, good enough to merit an invitation to the Washington, D.C., Cherry Blossom Parade in 1965. An eighth grader then, Shelley said that "the town did things beyond imagining to raise money for us"—*two* buses, one just for the instruments, plus hotels and meals. The students practiced music and marches every day for three months. "Marching down Pennsylvania Avenue was one of the proudest days of my life. That's the band from Lubec Maine and they may be small but can you hear them coming." Shelley said that music teacher Calvin Lowell was "strict but very nice."

"Our school band used to march on Memorial Day and the Fourth of July, and we played taps and they shot twenty-one gun salutes, and we would march down to the bridge after it was built, before that to the bandstand. We used to have Spring and Christmas concerts," Shelley said.

The Middle Years

"When I attended," said McGonigal, "the building itself was much the same as in 1916. The auditorium, used for study halls, remained on the second floor, where plays were performed including Christmas performances." Library facilities remained minimal. Annie Gerrish, longtime French and Latin teacher, told us that the library was a tiny room between the two staircases. Yearbooks of the era include many photos shot against the same bookshelves.

Julie Keene's mother did not graduate. "She got pregnant with me. You were an embarrassment to the community and you had to get married. My whole family was extremely religious, and that was a sin. You were expected to quit school."

Miriam Kelley attended during the World War II era. "Back then if girls got pregnant they were kicked out of school." She did not know how many, because living on a farm she heard less gossip from town.

John McGonigal recalled when a student dropped firecrackers down the fire escape. "The Principal grounded the whole class until we told who did it." Shelley Farmer related stories of a boy "always making trouble." One day in second-floor study hall, he opened a window and told the teacher that he was going to jump out of it; instead he *fell* out and broke his leg.

Guy Look, principal at the elementary school and then the high school, who ultimately served as superintendent for seventeen years, told of his own strategy for dealing with intractable troublemakers. He spoke to students first and told them not to do it. If they continued, he had a ruler in the office. "I don't think they did it again."

Look once told of a girl acting up. When he tried to pull her from her chair, he found that she had her legs wrapped around a table leg. "You win," Look said. "However, she never did it again."

Still, everyone spoke fondly of Guy Look. "He was a sweetheart of a guy," said current bus driver Keith Campbell, perhaps an unintended pun.

The Protest

America changed in the sixties and seventies, evolving into the egalitarian society long envisioned but seldom achieved. Minorities possessed rights; majorities, such as women and youth, did too. It was a time when people spoke out. "We all spoke out," recalled Julie Keene. Once, the high school administration terminated a favorite teacher over what students considered a trivial matter. The ferment of the era set the young people astir. "We didn't believe it was right, so we walked out of the school."

Lubec was then, as now, a small, close-knit community. The mothers of school kids worked in the packing plants and the fish factories, which bused employees to and from their homes. The hour of the protest coincided with shift shutdown, purely by chance as packing concludes when the fish run out. The factories, sardines fully packed, sent all the women home.

"It was the coolest thing," explained Keene. Typical of isolated seacoast communities and islands, families remained for decades and centuries. It

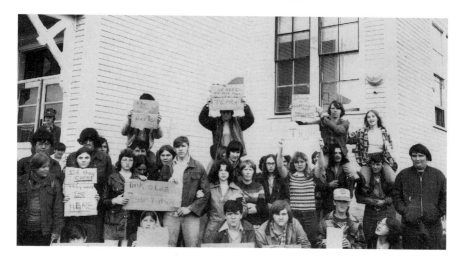

The student protest. *Shirley Morong photo.*

seemed that everyone was related to everyone else. Many of the women had kids in the high school, and since everyone seemed related to everyone else most people connected through students with the school. "Here comes the procession from the factories, and they saw us," said Keene.

Not your ordinary day, returning home weary and haggard from work, eager to bathe, remove fish residue, wash your hands and take down your hair. All of the women were still in their mandatory hairnets, "wild, radical women who were just sardine packers"—ordinary housewives who went to work every day, minding their own business and raising their kids. But they were also stimulated to anger over the teacher being fired. The outrage spread and multiplied. Those workers in cars pulled up, stopped and laid on the horns. "The women on the factory buses were hanging out the windows and yelling," said Keene, her eyes still reflecting her passion more than thirty years later. The fervor grew; the students rekindled. The students claimed that they were *never* going back to school until their teacher returned.

Preponderance of people power prevailed. The administration reinstated the teacher! "It was a good thing to stand up for what we believed in," added Julie Keene. "She was a really good teacher."

The Closing Years

Lubec voted for a new high school, passing a $2.5 million bond on March 26, 1975. In the last years, the building was condemned, with the top floor off-

limits according to Julie Keene. "One time we snuck up there and checked it out and it was awesome with that big stage." However Patsy Kelley said that a decade earlier "tapping your heels would cause the entire floor to vibrate in waves." Another former student spoke of the floor as "lumping up" unevenly. Age, not quality of the lumber, wedged the seeds of disintegration. From the beginning all of the rooms on both floors except in the basement featured hardwood flooring. When they tore the building down, people even scavenged the flooring.

"It Broke My Heart"

The wrecking crew from Machias began its grisly chore at 9:00 a.m. on September 21, 1978. A crowd gathered to view the annihilation. Chain and cables attached to a front-end loader pulled a beam, door or window frame, breaking loose a minuscule bit one fragment at a time. The old building fought stubbornly, "as though as part of the town's history it resented being removed," wrote longtime reporter Shirley Morong in the *Quoddy Tides*.

Almost six hours into the gruesome task came the last gasp. A rumble expanded to a roar, splintering timbers, shattering glass and a vast cloud

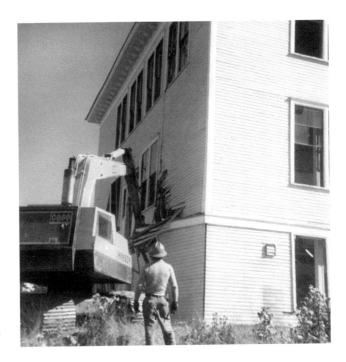

The wrecking begins.
Julie Keene photo.

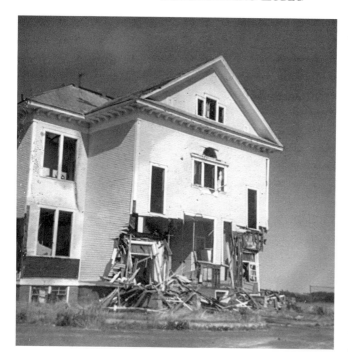

Razing the rear of the old school. *Julie Keene photo.*

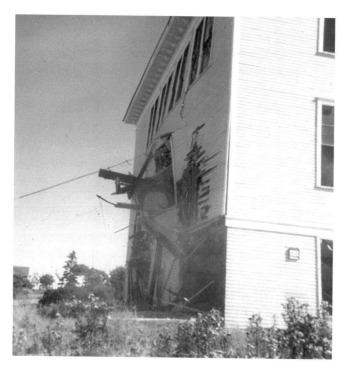

Pulling out a side wall. *Julie Keene photo.*

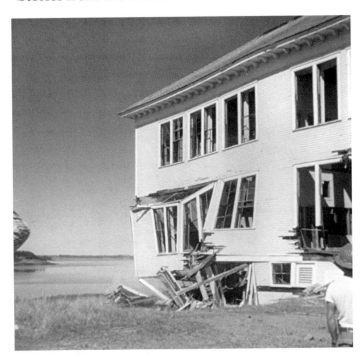

Buckling but
not down yet.
Julie Keene photo.

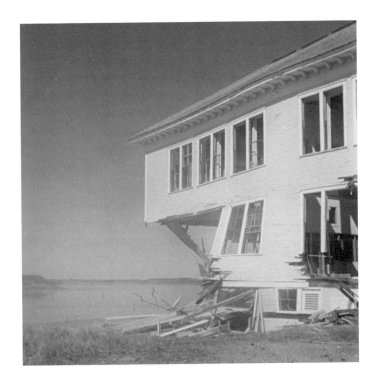

They built a
solid structure
back in 1915.
Julie Keene photo.

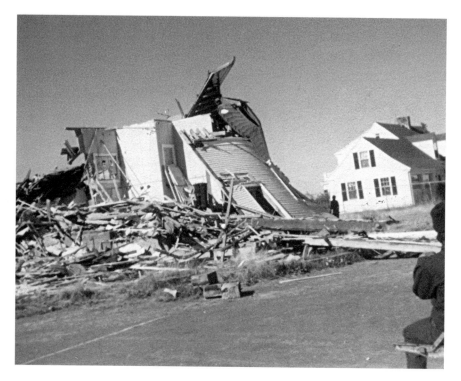

The high school building is gone, but the distant house remains as of 2009. *Julie Keene photo.*

of dust marking the end as resignation and tears flowed among the dour spectators.

What factors elicit such earnest affection for a seventy- by one-hundred-foot, ungainly timber structure? What leads young people to revere an antique edifice, motivating such ardor and loyalty? Perhaps an inseparable memory of youth, gone forever. Perhaps because we spend more childhood time in school than in any other place except home—"spend" because we spend our youthful years for the then incomprehensible rewards of an educated adulthood.

"I felt really bad about the old high school being demolished," said Shelley Farmer. She lived away from Lubec when the building came down, but when she returned and saw the barren site she felt devastated. "I knew it was necessary, a very old decrepit building, but something I felt really close to."

Patsy Kelley remembers her mother calling with news of the imminent toppling of the tall adolescent institution. She arranged a few days off from work and came home. "I wanted to take pictures before it was violated by the

wrecking crew." She parked across the road in the old McGonigal garage lot, where the kids with cars parked during school hours. "How many hours did I spend at that same spot with my friends and how many memories rushed into my head." That old building had housed multiple generations of high schoolers, even Patsy's father, Clayton, and the structure was antiquated then. "Not only in my years, but my father also went to school there, and the building was not new then." Every person who went to school there has a story to tell of LHS. "I took my pictures, smiled, shed a tear and left town. I miss the building not being there," said Kelley. Lubec High School was a veritable landmark for many years.

Retrospective from Those Too Young to Remember

The fifth-grade students who assisted with and helped write about the interviews were asked what the research taught them.

"I learned that the old high school had no art room and no gym. But there were more activities back then," said Seth Doherty. Back then was a time with larger population in Lubec and far more students. "I learned what the old high school meant to a lot of people. I wish it had a gym." said Robert Wallace.

The girls wrote comments, too. "One thing I disliked was home economics. I don't like the thought of being taught how to do those kinds of things, because those are the things your mother teaches you," said Emma Page. "I like the ways teachers were. They are like always ready for what's ahead of them," said Stephanie Wright.

These students interviewed elderly superintendent Guy Look. When asked what he enjoyed most about his job, he snappily answered with a grin: "Recess." But when queried about the demise of the old school, he said simply, "Lonely, lonely."

THE SARDINE WORKERS

Y ou always worked seasonally. You needed fish in the factory for a call to come work," said Shirley Moores of Lubec, a longtime Lubec sardine packer. The variation of the catch always defined Lubec economy, and the fortunes of myriad workers, over the decades and centuries.

Under best conditions, the packing season closed by November 15, not opening until herring began running about mid-March. And conditions remained as uncertain as the sea's supply of herring.

Yet young Lubec prospered from timber and the wealth of the sea. An 1829 *Survey of Maine* found that in relative wealth, where the average is 100 percent, 1790 Washington County registered 69 percent, down in 1800 to 63 percent. But in 1810, the year preceding Lubec's founding, it was 103 percent. By 1820, statewide relative wealth reached 117 percent. During these two early decades, Washington County wealth was second only to Cumberland County and Portland, the largest city. Clearly Lubec was off to an auspicious start, fueled by the hardworking population.

Herring

Human beings smoked meats for preservation from time immemorial. Smoking of the prevalent fish of eastern Maine's waters grew from the early nineteenth century, especially after the once-towering abundance of cod declined. Herring smoked efficiently, kept well and tasted good.

The word herring connotes a family of species common to northern seas. Larger examples were smoked. Modern practice defines the "sardine" as under ten centimeters or about 4.3 inches long; many are smaller, some larger. Moving in vast schools, herring catch easily in weirs, water cages fabricated from vertical poles with a funnel-shaped entrance impossible for

the none-too-smart fish to escape. Small-scale weir catch simply waited for low tide. Commercially, seiner boats pull in a giant net called a seine. A rope running through rings along the seine edges acts as a drawstring, pulling the net closed, hence the name "purse seine."

Initially, large-scale smoking along the Maine coast utilized herring from the Magdalen Island archipelago in Gulf of St. Lawrence, part of Quebec out toward the Maritimes. According to the book *Maine Sea Fisheries: The Rise and Fall of a Native Industry*, "By 1890 Lubec was putting up more than half of all smoked herring in U.S.," with smaller herring found locally in Passamaquoddy Bay.

Development of Sardine Canning

The year 1890 witnessed canning of small herring as sardines solidly established. Almost two dozen factories sprang up, initially on North Lubec but quickly spreading to Lubec village. These factories packed almost 1.2 million cases in 1899, but variable annual catch combined with fierce competition depressed profits.

A January 21, 1937 column in the *Lubec Herald* related how competition led to "clipping," that is, placing fewer fish in each can, using salt water in place of salt; vinegar and turmeric in place of mustard; and fish oil rather than olive or cottonseed oil. "It all helped to pile up fortunes…there was apparently no honor in the business whatever." The editor accused the early sardine barons of "Wall Street tactics," issuing stock in excess of what the business would stand in violation of the Sherman Anti-Trust Act. "It was seen by the men who made Lubec what it was and is, that something had to be done."

Doing Something

Consolidation at the Seacoast Canning Company at the turn of the twentieth century soon collapsed, and larger syndicates formed, often under secretive circumstances. The June 22, 1910 *Lubec Herald* reported that "independent packers charge that Seacoast Canning Co. violates Sherman Anti-Trust Act. Federal grand jury failed to return indictment." John Gilman's *Canned: A History of the Sardine Industry* presents a detailed account of the Machiavellian convolution and positioning of the business.

Even the biggest remained at the mercy of catch variability. On August 2, a cautiously optimistic *Lubec Herald* wrote that "receipts of herring at the

factories the past week have been of an encouraging nature…all the shops in town have now begun to take fish." Yet the newspaper's editorial on November 2 warned of declining herring population.

Little changed over the decades. A sampling of the newspaper in 1947: February 20, awaiting state legislative action to permit sardine factories to open one month early; February 27, factories expected to open on March 3; and April 17, February fish landings down.

Cans for Canning

For more than a century, fish were Lubec's gold, evinced by the glinting of millions of metal sardine cans, and the heavy aroma of the smoking process was the pungent scent of prosperity.

Skilled workers fabricated cans by hand from tin-plated sheet metal, while equally skilled men soldered the lids after packing. Solder contains lead, sometimes leading to often unrecognized poisoning among individuals consuming much canned food. Canning in metal commenced in the late nineteenth century, with machine-made cans arriving in the 1890s. The turn-of-the-century sardine syndicate held valuable sardine can patents, which led to the giant American Can Company monopoly. Twentieth-century can technology increased speed and quality and led from viscous sealing fluids to tightly crimped hermetic seals—and to work for all. According to *Canned*, by 1927 can plant workers earned thirty cents per hour, with growth assured by the war and subsequent social prosperity. Yet always did variability of catch determine the bottom line. Scarce herring in 1955 resulted in just seventy-five part-timers, yet in 1961 two hundred employees worked three shifts per day.

Prosperity is relative, though. The word may connote affluence or merely the assurance that if the herring run work follows. "When my mother went to high school in the late fifties," said Lubec native Julie Keene, "the whole town was working." Julie told how her grandmother skinned herring for one dollar per barrel to make enough money to buy Julie's future mom a prom dress—"cold, horrible, painful work."

"Off season we worked at what we could," said Shirley Moores. "Many Lubeckers wreathed, and still do." At year's end, the hand manufacture of evergreen wreaths, also seasonal, brought food money for little cash overhead. Others in the family went out "tipping," acquiring suitable tips of evergreen boughs, assembling into wreaths on wire frames and selling to wholesalers for marketing, literally Lubec's cottage industry.

"We got by fine," said Shirley. "We generated no waste. We figured out what you can use it for until you get all the good out of it and little was left."

Origin of the Sardine Industry

The early smoked herring industry originated as a low-tech business. Even distribution required no metal cans, only wooden shook boxes. Shooks, the unassembled parts for boxes, grew as a companion industry in the softwood-rich wilderness of Maine shook trade, which peaked in the late 1870s and 1880s. Cutting lumber for shooks was big business for some Maine lumbermen. Maine even shipped its pine to Europe (Italian fruit was packed in Maine boxes).

Table 1

Year	flour	1 lb. steak	1 qt. milk	10 lb. potatoes
1890	.15	.12	.07	.18
1910	.18	.17	.08	.17
1930	.23	.43	.14	.36
1950	.49	.94	.21	.46
1970	.59	1.30	.33	.90
1975	.98	1.89	.48	.99
2009 Lubec	2.69	2.69	1.99	3.99

U.S. Bureau of Census, Historical Statistics of the United States from Colonial Times.

The post–Civil War period generated a mushrooming of factories, capping the Industrial Revolution with tens of millions of factory workers accompanied by lunchboxes. A can of sardines for that lunchbox cost five cents in 1910, when butter sold for twenty-five cents per pound and eggs thirty cents per dozen. A seafood diet promotes health with high protein plus vitamins, which were just being isolated in the teens of the last century. We know now that sardines are also low in toxins such as mercury.

Early Working Conditions

Yet the prevailing working conditions to pack sardines, by modern standards deplorable, combined with long hours six days per week in season. Even then women performed the sardine-packing process, with children often being used as cutters.

Factory photos with workers called out to the camera artist abound in this era, the justification not being at hand. Well justified by sociological concern are the thousands of images photographed by Lewis Hine, crusader against the misery and danger of child labor. The Library of Congress holds over fifty fish factory images from Eastport, Maine, but only two recorded in Lubec. Never one to shirk from editorializing, Hine noted on his negative that few children are employed here "but are likely to be as the process is cheapened." His photograph shows the factory surrounded by workers' houses.

"Sardine houses" proliferated in this coastal region, typically about twelve by twenty feet with a loft. Many remain, nearly all expanded, while many others were moved to other sites. Some retain evidence of life one hundred years ago in the form of old newspaper insulation. In 2008, the house in

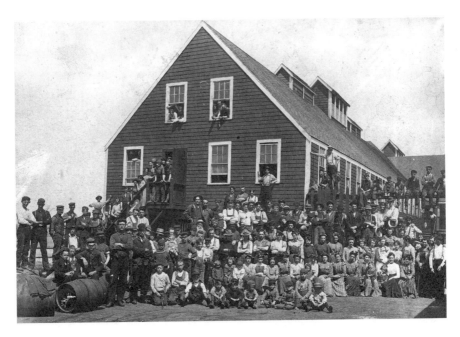

Sardine plant workers, early twentieth century. *Lubec Historical Society.*

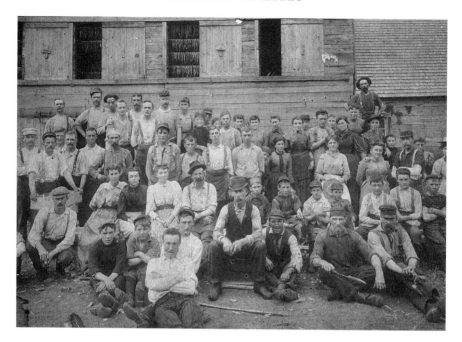

Smokehouse workers, early twentieth century; note the children in the middle, on the right. *Lubec Historical Society.*

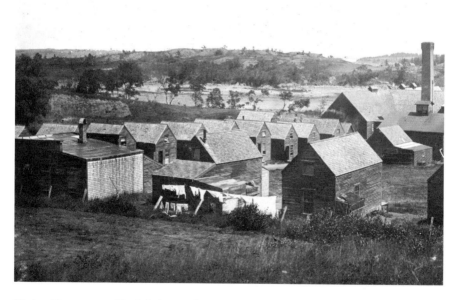

Workers' houses near North Lubec sardine plant, 1911. *Lewis Hine, Library of Congress.*

Surviving sardine workers' house. *Ronald Pesha.*

the photograph here still stood, an added seaside "picture window" once installed by some enterprising resident.

The Maine Historic Preservation Commission lists the "sardine house" at 163 Main Street as #253-0017.

Child Labor

Early state statutes limiting child labor pervasive in most industry across the nation met minimal success. In 1916, a federal child labor law prohibited interstate commerce where minimum age laws are violated. The Supreme Court found this law unconstitutional in 1918. The justification was that the Constitution fails to mandate child labor statutes and thus under the Tenth Amendment only states may do so.

Congress attempted to pass a 1924 introduction of a constitutional amendment that would authorize a national child labor law; however, this measure was blocked by opposition within Congress.

Finally, in 1938, President Franklin D. Roosevelt signed the Fair Labor Standards Act, which includes limits on many forms of child labor. Prohibited employment of minors in "oppressive child labor" means employment under which "any employee under the age of sixteen years is employed by an employer...in an occupation other than manufacturing or mining or an occupation found by the Secretary of Labor to be particularly hazardous for the employment of children."

The Apex of Affluence

The rich sardine factories of Lubec faced competition from Norwegian and Portuguese sardines, packed in places where wages were a quarter. But the gathering clouds of war cut off those sources, and with the outbreak of hostilities the U.S. War Department contracted for three million one-hundred-can cases per year, not for the omega-3 fatty acid content but as portable nourishment that would not spoil.

To meet that demand, Lubec plants worked to increase 1941 sales by one million cases. A popular family-oriented weekly magazine of the era, the *Saturday Evening Post*, documented the successful effort in a major article published on January 16, 1943.

The story told about the fishermen remaining after most young men were drafted and how the women packers all worked overtime. Signaled in early by factory whistles near dawn, four hundred or more women filled the little cans by hand. "Modern conveyor systems and automatic machines do everything else, but no one has succeeded in making a machine that can match women's facile fingers in grading sardines, snipping off heads and tails, and laying them neatly in cans, with motions so swift that hands blur before the eyes."

After a couple hours, the women return home to serve breakfast to the kids and pack them off to school. They may respond to whistles two or three more times before day's end. Everybody is on call day and night, except Sundays. They plan on hitting that three-million-case goal next year. The long, lean years of the thirties well past, the welcome burgeoning income bought good times.

Men's incomes swelled, comfortably secure for raising families but leaving the women's wages at bonus status. "That's the Lubec plan," wrote the *Post*. "The men pay the regular household expenses, the women save their money to educate the children. No Maine town sends a larger proportion of its boys and girls to college."

Suctioning herring from boat's hold. *U.S. Fish and Wildlife Service, F.T. Piskur photo.*

From a robust business at war's end, sardine canning plunged into lethargy by the 1960s. Overbuilding during those halcyon years combined with loss of tariff protection to decimate the once-flourishing industry. However, work remained, again seasonal, with improved technology.

Each carrier brought in the catch, which suctioning speedily removed from the hold. Only men unloaded. "A Dr. McCallister, who was here only about a year or two, said he felt that the women worked harder than the men," said Shirley Moores. The women stood on their feet five or six hours at a time with their hands in cold fish. "We developed trouble in our legs and backs," she said, "arthritis in one place or another."

After suctioning the catch, a sluice directed the fish to the brine vats. Vats held the fish until conveyor belts directed them to the women, who prepared them in hairnets and plastic aprons. "A lot of stuff was flying around," said Shirley. "Then you get your fingers done up"—taping them for protection against cuts.

Shirley admitted that she was nowhere near the fastest, for some women could pack five or six cases an hour. But then perhaps no more work became available for a week or two. Calls might come at 7:00 a.m., or women waited

Fish sluice. *U.S. Fish and Wildlife Service, F.T. Piskur photo.*

until mid-morning or mid-afternoon for the factory whistle or a telephone call. "When there was work, you were ready to go."

Packers like Shirley used scissors to cut off the heads and sometimes the tails. The women scooped the fish off the conveyor belt, usually with their arms, and then snipped. "Sometimes I packed steamed fish, but you had to be very careful or you'd break the skin." When Shirley first started, she packed raw herring. "It made a better-looking fish."

Cooked fish require razor-sharp scissors. Right-handed women taped their left fingertips. The scissor-wielding right hand bore tape on the base of the thumb and the second or third finger. Women provided their own adhesive tape.

Four pans or trays of cans filled a case, twenty-five cans to a pan. Jerry Rahilly started with a low-status job, placing the pans ready for the packers. Another crew took the cases (four pans or one hundred packed cans) for precooking, steaming thirty or forty minutes. Then they were off to drying, where the condensed water drained before they were sent to sealing room. The machine-sealed cans spent nearly an hour in the retorts (analogous to

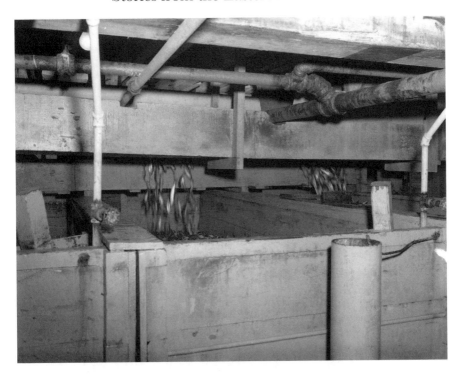

Fish held in brine vat. *U.S. Fish and Wildlife Service, F.T. Piskur photo.*

a pressure canner) at 242 degrees. Before packing came "picking off"—workers inspected each can for unsound seals, dents and other defects.

Jerry Rahilly eventually settled into a second job, selling bait to lobstermen. "Every part of the fish over four inches had to be clipped off," Jerry explained. The fish waste went into a scoop cart, recycled as bait. "And I loved the work. People were great there, always laughing." Rita Rahilly concurred. "I'd go right back if the sardine business revived," she said. "We all knew each other and what everyone was doing." This is one of the advantages of a small town, even though some weeks brought forty hours of work, sometimes eighty and some weeks very little.

The uncertainties remained a fact of life. By this era, herring rarely ran strong before July. Lubec's Moses Pike ran a plant in Eastport from 1937 to 1979, and in a 1983 interview he said with the knowledge of decades (he was then eighty-six) that "it's the variableness of the size of the pack that causes so much trouble." In 1982, his old plant had packed well over 600,000 cases of sardines but the year before exceeded 1.2 million. To deal with the problem, Mose would never revert to price cutting. You can knock down the price in two days, he said, but you need months to get it back up to normal.

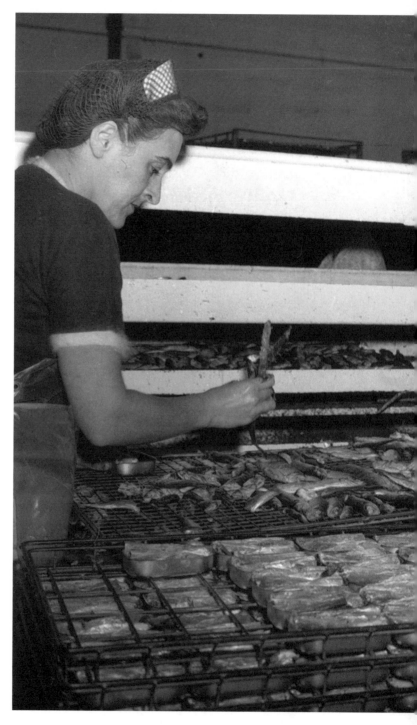

Packing sardines. *U.S. Fish and Wildlife Service, F.T. Piskur photo.*

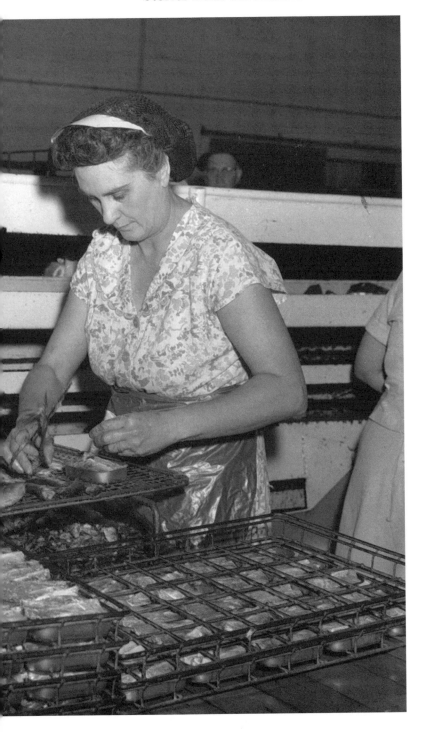

Going pay in 1983 reached $2.50 per case, piecework. Everything else was automated. A good packer managed three cases per hour at four fish per can, or at six fish to the can, two and one-half cases per hour.

Shirley Moores explained that the smaller fish required more time because more fit into a single can. "The Forelady packed a few cans to determine how many fish we should pack into each can" She added that they came out almost equal in weight.

"Packers called to work stayed until all the day's catch were packed, as no refrigeration existed," Shirley said. Packers called in late in the day might remain on the job until 1:00 or 2:00 a.m. "Later on refrigeration made work a lot better."

The regular grade of sardines bore larger fish. Cans containing smaller "higher grade" fish were wrapped in paper labels. The higher, fancier brand was the same lot. "The only difference was the can top," she explained.

During those years of war, R.J. Peacock and Seaboard Packing operated factories in Portland, Rockland, Robbinston and nearby Perry. All downhill from there, Maine sardine plants declined from forty-eight down to fifteen in 1975; soon only two remained, Peacock and Booth, both in Lubec.

Waste fish inevitably arrived with the herring—pollock or mackerel mixed in. "We women would take home and can or 'jar up,'" said Shirley. Not only the workers but also anyone in town would go to the fish tank room and ask to have some picked out or pick out the fish themselves. In fact, that was one of the perks, Shirley added. Some cans of sardines just disappeared. A few cans at a time.

"It was part of your job."

SAVING HISTORY

History teaches change. Society differs today from a decade ago, a generation, a century or more. Children, who tend to live in the present, only gradually begin to comprehend that change inevitably affects their futures in myriad transcendental ways. They come to realize that mature adults practice saving for the future: saving income, saving health and saving the earth and its fragile environment. Change happens. You, too, can save history. Write a memoir, a journal or a letter to your children and grandchildren about yourself, your values and your ethics. Just don't expect a CD or even flash memory or a thumb drive to be readable in a century. Use a pen or pencil, simple technology with long life spans, on archival paper if you can.

Photography

A picture is worth how many words? Attempt to describe a scene from the past—your childhood house, your elementary school—perhaps now gone. A photo shows it in a flash. A recent photo compares *changes*. Most people find it fascinating comparing old and new photographs.

This fine old photograph of Water Street, "downtown" Lubec, offers a view rich in content but, alas, lacks exact dating. Note the juxtaposition of an early automobile, left, which assists dating, with a carriage, right, and the profusion of telephone and electrical power lines.

The brick bank building just beyond the trees was built in 1911. Only two brick structures (the other an old jail) existed in old Lubec, both still extant, as are many of the wooden buildings and houses. Unlike so many older communities, Lubec never suffered a massive and widespread fire.

On the left, Clark's dry goods and furniture store dominates the photograph, then Mabee Apothecary with its false front (now 37 Water Street) and the

The bandstand from color postcard. *Lubec Historical Society.*

The bandstand in 2009, still used regularly. *Ronald Pesha.*

Water Street, downtown Lubec, circa 1911. *Lubec Historical Society.*

Water Street in 2008. *Ronald Pesha.*

Flatiron Corner in 2009. *Ronald Pesha.*

W.A. Brown clothing and shoe store. (The latter no longer appears in the 1912–13 *Maine Register*, which assists dating.) Note the slight hump in the street, after a century still obvious in the contemporary photograph. The brick bank building remains, façade modified; it is tourist lodging in 2009.

Just a block off Water Street lies Monument Lot, and across Main Street on the corner of Main and Pleasant Streets lies the bandstand. Other than the Knights of Pythias Hall seen behind the statue, all else remains, the bandstand having been rebuilt more than once.

The incoming road, now State Highway 189, forks on the outskirts of town, a configuration long called "Flatiron Corner." Highway 189 continues on to the left, Washington Street, while Main Street junctions from the right. Compare this photo with images in the seventh chapter. The Forewinds House still stands, far down the road visually, just right of the nearest utility pole, now red rather than white. During the century-plus span of time between photos, a large high school building to the right of the road came and went.

The house so clear in 1890 across the road from Forewinds remains, a restaurant since 1980. Subsequent construction obscures the structure in the contemporary photograph, as do trees. Earlier centuries, dependent on wood for warmth and local lumber for construction, denuded the landscape.

Documenting Today for Tomorrow's History

You, too, can save images of history with your camera.

Most people photograph their friends, families and children. Include your surroundings. Commonplace, mundane scenes of today become the history of tomorrow. Photograph business and residential areas of your town or city, even the house or apartment where you live or your work venue. Document the results and store safely. Like a bottled note thrown into the sea, someone may stumble across your pictures decades in the future.

Media

The now ubiquitous digital camera comes in all price ranges, but what about archiving? CDs? Dye layers in CD-Rs have limited life spans. Flash drives or camera memory cards? How will researchers of the future access the images and data on a 2050 or 2100 computer? Remember when you entered precious data on $3\frac{1}{2}$-inch "floppy" discs?

What about film cameras? The 35mm film format introduced by Edison and Eastman remains readily available. From common modern photographic prints properly protected one can expect a good half century. A time capsule buried at West Quoddy Head Lighthouse in 2005, due for disinterment in 2058, contains a CD but also color prints on paper. Expect stability from top-brand photographic papers, which must survive saturation without warping or disintegrating.

If you do shoot digital, pay professional prices for archival-grade inks and papers, a rapidly evolving technology.

Camera Choice

Emerging "stitching" technologies permit seamless matching of multiple or even hundreds or thousands of photographs. But let's consider simple, basic still photography. Regardless of film or digital, use a quality camera with a sharp lens. Eschew single-use supermarket cameras. If a novice, ask a photographer to set you up with standard exposure and focus settings. Then shun dim light. Most inexperienced photographers photograph people from excessive distance. Close-ups are great if you know how to focus or if your camera focuses automatically.

Taking the Picture

- Hold the camera steady and *level*, difficult with a digital camera lacking an eyepiece and holding the camera at arm's length. Try sitting backward on a chair, resting the camera atop the chair's back.
- Look at the background in the viewfinder. Does it have intrusive elements, such as power lines? Or does the background help place the location?
- Press the button slowly and firmly, a gentle squeeze. Refrain from jabbing it and shaking the camera.

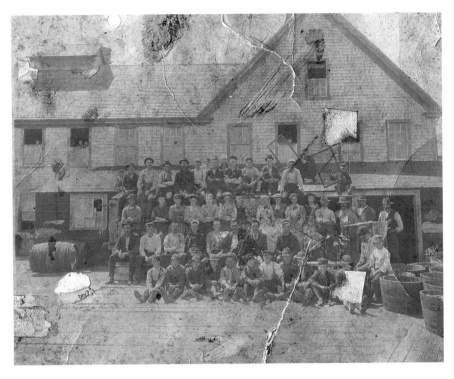

A severely mistreated vintage photo. *Lubec Historical Society*.

Documentation

Record your information. Historians like exact dates, precise locations and names but care little for lens settings and shutter speeds. For historical purposes, create a record, not art. Number the prints and accompanying documentation to correspond, using archival paper and ink.

Prevent fading and mold. Store in low-acid boxes or albums away from light and in a dry location. Avoid future generations finding a marred image.

THE NAMING OF LUBEC

Lübeck, Germany, of course, is the godmother of our town. The Maine edition of the famous WPA Federal Writers' Project travel directories written in the 1930s casually states that the town was named for Lübeck, Germany. The locally published *Illustrated Souvenir 1908* opens: "Named for Lübeck in Germany, yet settled first by the French."

In the twenty-first century, Lubec remains remote and was certainly perceived as a primitive outpost two centuries ago. Originally part of the city of Eastport across the bay, early attempts at incorporation about 1790 failed partly because the area remained in dispute between the United States and Britain and partly because of the distance from centers of government and population.

Meanwhile, farming settlers had occupied a peninsula across the strait from Eastport known as Soward's (or later, Seward's) Neck. In 2008, Lubec resident Ruta Jordans confirmed that the earliest known map of this area, now called North Lubec, shows no place names whatsoever. Jordans searched the survey in a book labeled "Seward's Neck" at the county courthouse in Machias. She found neither "Lubec" nor "Lubeck," only the owner name for each parcel of land. Nearly all of these surnames remain common in Lubec to this day: Allan/Allen, Avery, Bowman, Clark, Gove, Huckins, Reynolds, Ramsdell and Small. Also residents were French-named Louis Delesdernier and his nephew Nehemiah Small.

With uncertain jurisdiction, Lubec or Lubeck was something of a "free town." Popular theory suggests that Lubec was named for the Hanseatic town Lübeck, then a free state in Europe.

From the thirteenth into the sixteenth century, Lübeck maintained itself as the most powerful member of a Hanseatic medieval economic organization, controlling Baltic trade. Lübeck lost importance after the Hanseatic League was essentially disbanded in 1669, remaining an active Baltic Sea trading

port with social customs uniting people known as Hansa and persisting into the 1930s.

In 1907, the Lubec Canning registered a double eagle trademark for its Eagle Brand sardines. The double eagle appears on the Lübeck flag.

The earliest settlers about 1758 were French people including the Delesdernier family. English and Scottish arrived from Nova Scotia in 1776. Among these was Scotland-born John Allan, who offered significant service to the Americans during the Revolutionary War. Yet *Maine Place Names and the Peopling of Its Towns* writes without specific evidence that "it may well be supposed that some Germans had settled here, since when the town was incorporated in 1811 it was named for the good old German city Lubeck, in which form the word appears in the act of incorporation."

No Germanic names appear among the first residents of the new town, yet about 1810 these inhabitants selected "Lubec" as the community's name, for a new petition in 1810 so specified. Why? Kilby's *Eastport and Passamaquoddy*, regionally considered a seminal exposition of local history, offers this:

> *At the annual town meeting, April 2, 1810, it was "voted that a committee be chosen by the people of Sowards Neck to petition the legislature of Boston to be set off from Moose Island and be a town or district by itself "; and Samuel Yeaton, Joseph Clark, Jr., and Benjamin Reynolds were appointed the committee. The petition signed by this committee asks "that all that part of the town called Sowards Neck, Denbos Neck, and all the parts not connected with Moose Island, may be set off into a district by the name of Lubec, because, among other reasons, their interests which are agricultural are materially different from those of Moose Island, that the municipal regulations require a different arrangement, and the parochial and pecuniary concerns, a different management," etc.*

Among the names suggested was the Indian "Kabaumkeag," which was rejected as clumsy. "Seward" and "Lederny" (sometimes interpreted as a corruption of the name of L.F. Delesdernier) were also considered.

Kilby's account says that Jonathan Weston, who surveyed most of the lots in the town and had traveled abroad, suggested that it be named "Lubeck," after one of the German free cities, because of its shape, location and the fact that trading was as *free* as anywhere in the country.

> *The petition is in the handwriting of Jonathan D. Weston, at whose suggestion, as I have heard, the name of Lubec was selected. It bears an indorsement [sic] showing that it was sent to be presented at the May session, but was received too late for action.*

Stories from the Easternmost Point

The following session is that of the State of Massachusetts, meeting in Boston—at this date it was still a district of Massachusetts.

> *Next year, April 1, 1811, a committee of six was appointed to draft a bill for the separation of Soward's Neck from Moose Island, consisting of Jonathan D. Weston, Jabez Mowry, Sherman Leland, Samuel Beals, Joseph Clark, Jr., and Benjamin Reynolds; and at a later meeting, May 6, it was voted to accept the draft of the bill reported by this committee… Lubeck, as the name is spelled in the act of incorporation, which is dated June 21, 1811, was the one hundred eighty-eighth town in Maine.*

The charter is actually dated June 19. Governor Elbridge Gerry signed the document on June 21, 1811, officially creating the "Town of Lubec" as separate from "City of Eastport," known as Separation Day. Incidentally, the chair signatory of the town charter was Joseph W. Story, Speaker of the (Massachusetts) House, who within five months became the youngest person ever appointed to the U.S. Supreme Court, on which he served for thirty-four years until his death. The storied associate justice delivered the "Opinion" in the *Amistad* slave-trading case, portrayed in the 1997 movie of that name.

The draft bill indeed spells the name as "Lubec." In 2003, an acquaintance of Bernard Ross of West Lubec found the document in Boston petitioning for separation of Lubec from Eastport, along with the acceptance of the document by the Eastport town clerk, Thomas Burnham. Ross reports that his friend acquired a copy of the original request document drawn up by three individuals who were appointed by the citizens of Eastport. It was a surprise to find Lubec spelled as such, without the *k* like the city in Germany, even though that was supposed to be the origin of the selected name. Ross says that he also examined the final parchment that was signed by the officials and the governor of Massachusetts granting the separation. "This document contained LUBECK spelled like the German City," Ross wrote.

Why did the local committee select the spelling "Lubec"? Why did the commonwealth of Massachusetts legislature add the *k* to the end?

The Lubeck charter reads: "Sec. 1 Be it enacted by the Senate and House of Representatives in General Court assembled and by authority of the same. That all that part of the Town of Eastport, as contained, and described within the following boundaries be, and the same is hereby established, as a separate town by the name of Lubeck." The handwritten document repeats "Lubeck" eight more times.

Numerous legends suggest people other than Jonathan Weston for originating the name. Another version originates in this account by Ronald Pike:

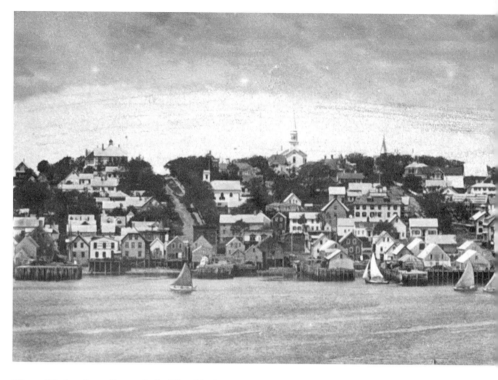

View of Lubec from Campobello Island before 1900. *Lubec Historical Society.*

Moses Pike (ca. 1785–1862) was Captain and probably owner of the "Barque Abo" which was engaged in what was called the Baltic trade in naval stores, including rosin, turpentine and hemp. Legend has it that the "Abo" landed here from the Baltic in June 1811 when the citizens were trying to decide what to name the town (recently set off from Eastport). Somebody in the crew said that this village looked very much like the city of Lubeck, Germany where they had called on their way back from Finland, and as nobody could think of a better idea, that's how the town got its name.

Kilby stated that the original document prepared in 1810 bears the name "Lubec." Yet Pike wrote further that "Moses was still living in Salisbury, Massachusetts, in 1810 when the father of his wife Sophia Marston, came down there to visit them."

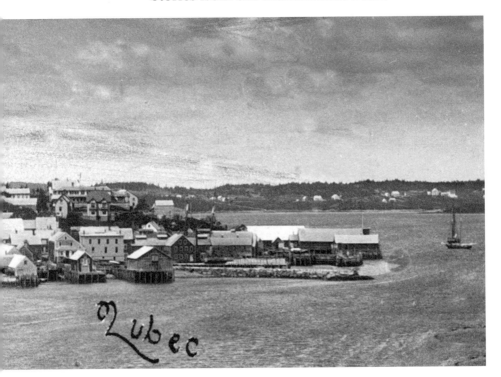

A Lubeck in the United States

An American Lubeck exists, a small community outside of Parkersburg, West Virginia, clearly named for the German seaport, both by spelling and historical record. *A History of Wood County* (West Augusta Historical and Genealogical Society, 1980) includes an account by Miss Hattie Bartlett "Written About the Year 1885." Miss Bartlett says that the community was founded in 1841 as Watertown and known by that name "until the settlement here of Mr. Slevogt, a native of the city of Lubeck in Germany who, no doubt, could not forget his early home beyond the deep blue waters."

Other Lubec Place Names in the United States

In 1908, the U.S. Forest Service constructed a ranger station in the Montana Rockies, an area that later became Glacier National Park. By 1930, under the aegis of the National Park Service, additional buildings including a barn and new ranger office became known collectively as the Lubec Ranger

147

Station. No source for the origin of this name was available to this author, but apparently the backcountry facility was abandoned after 1977.

Lubec Streets exist in Boston—East Boston, Massachusetts; Providence, Rhode Island; and Downey, California. Neither the Downey Public Library nor the local historical society in Downey could locate any details on the origin of that street's name.

A French Source for the Name

The 1811 Lubec census lists all families, none with an obviously Germanic surname. The early map of Seward's Neck, later North Lubec, also shows none. But the French-named Louis Delesdernier was a prominent citizen.

John Gallagher, with Nicole Fourmond Moores, points to a preponderance of French place names in the immediate area, such as St. Croix River, Calais, St. Andrews (St. Andre), Harbour de l'Outre on Campobello and many others. Among the prominent scions of early Lubec is Louis Delesdernier, possibly corrupted into Lubec's Ledurney Point according to local legend.

> *It is our contention that this origin (Lübeck) is so unlikely as to make it virtually impossible. Lubeck in Germany was an important port on the Baltic Sea in the Middle Ages, but had become of minor importance by the early nineteenth century, having been overtaken by Hamburg and Bremen… one must ask why settlers of English extraction with no interest in seafaring (at that date) would name their town after a dying German seaport.*

These individuals lived in the geographic district of Eastport known as Soward's Neck, later Seward's Neck, which became known as North Lubec. "The French would have named what is now Lubec (either Seward's Neck or Lubec Neck) LeBec (translation: the beak)."

Indian Place Names

Could a Native American root suggest an origin for Lubec? Similar proper nouns in the region include Quebec and the Kennebec River and Sebec Lake in Maine. *Québec* comes from the Míkmaq and Algonquin Cree word *kepék*, meaning "strait" or "narrows."

The modern Lubec village borders Lubec Narrows, the strait between the U.S. mainland and Campobello Island, New Brunswick. This is an ocean

strait, at one point just 150 yards wide. Another native word, *supeq*, means salt water or ocean.

As for the p/b confusion, Fannie Hardy Eckstorm points out that the sound made by the letter "b" (as in Lubec) does not exist in the Algonquin language family. She agrees that *kepék* means "narrow water": "Kebec contains the root *keb* or *kep* something that is closed in, contracted, plugged. It is the same word as Quebec."

Eckstorm adds, "The French were apt to omit [the locative sound of "k"] from Indian words which they adopted, but the English usually kept some form of the locative." In grammar, the locative case indicates a noun about place or place where. Thus, "Lubec" might represent "narrow passage" and "place," which together accurately describe the region of today's Lubec village.

However, occupants of Seward's Neck or North Lubec sent the petition to the state legislature. Only two houses existed in the wooded wilderness of what is now Lubec village in 1810–11. No evidence suggests that those North Lubeckers planned a move. Settling of that channel's shore came about when merchants and others in British-occupied Eastport decided to move away about 1815.

The 1910 suggested name "Kabaumkeag" is a Malicite or Abenaki word meaning "stopped up by sand bars," according to *Indian Place Names of New England*. Sandbars abound, but anyone observing the riptides through the channel would reject "stopped up."

Early Usage of the Town Name

When the submitted petition for formation of Lubec arrived as a charter signed by the Massachusetts legislature and governor bearing the name "Lubeck," the new town government continued to use the latter spelling. The book *History of Washington Lodge No. 37 Lubec Maine 1822–1890* points out that the initial town meeting minutes in 1811 spell the name with a *k*. Examination of town records shows that this spelling continues to 1818, though intermittently in the last months. Consider this report from "Lubeck" on April 23, 1817, in the grand flowing hand of William Hart, town clerk.

A couple of weeks later, a document reads "Lubec May 5 1817," in *another* hand but attested to Mr. Hart per his signature.

Town report, "Lubeck," April 23, 1817. *Lubec, Maine Town Hall.*

Town report, "Lubec," May 5, 1817. *Lubec, Maine Town Hall.*

Further Research

Needed is an anthropological linguist or lexicologist to quarry deeper into the sources of the name Lubec. Is it indeed named after the city of Lübeck as most believe? Or is it derived from French or Native American languages? Perhaps another yet unknown source or individual of 1810, or 1817, bears responsibility for the naming of Lubec.

BIBLIOGRAPHY

The Easternmost Point

Burrage, Henry S. *Maine and the Northeastern Boundary Controversy.* Portland, ME: Marks Printing House, 1919.

Eckstorm, Fannie Hardy. *Indian Place-Names of the Penobscot Valley and Maine Coast.* Orono: University of Maine Press, 1978.

Greenleaf, Moses. *A Survey of the State of Maine.* Augusta, ME: Maine State Museum, 1971. First published 1829.

Jackson, Charles T. *First Report on the Geology of Maine.* Augusta, ME, 1837.

Kilby, William Henry. *Eastport and Passamaquoddy.* Eastport, ME: Edward E. Shead & Company, 1888.

New Bedford Mercury, April 21, 1836. Untitled clipping courtesy of Jeremy d'Entremont.

Williamson, William Durkee. *The History of the State of Maine: From Its First Discovery, A.D. 1602, to the Separation, A.D. 1820.* N.p.: Glazier, Masters & Smith, 1839.

West Quoddy Lighthouse

Bureau of Parks and Lands/Maine Department of Conservation. Two-page undated document about West Quoddy Lighthouse. Original copy of

mimeographed document located in West Quoddy Head Light Keeper files.

———. "West Quoddy Head Light Station History." Augusta, ME: Bureau of Parks and Lands/Maine Department of Conservation, circa 2003.

Cranmer, Lee, historical archaeologist, Maine Historic Preservation Commission. Personal correspondence September 2, 2008.

Eastport Maine Sentinel, September 8, 1808.

Jackson, Charles T. *Atlas of plates illustrating the Geology of the State of Maine accompanying the first report on the geology of the state*. Engraving and lithography by Thomas Moore. N.p.: State of Maine, 1837.

Levy, Marsha. Letter to Jeremy d'Entremont, June 21, 2004, shared with author via private correspondence.

Lincoln, Benjamin. *Boston Columbian Centinel*, June 17, 1807.

Sproat, J.R., commander, U.S. Coast Guard Group. Letter to Ken Black, May 27, 1995. Located in Lubec Historical Society files.

Trapani, Bob, Jr. "More than Just an Oil House." *Lighthouse Digest* (October 2005): 30.

A Signature Quilt and the Search for Roots

Josselyn, Betsey Leavitt. Extensive correspondence with author.

Building President Franklin Roosevelt's Bridge

Barnard, Everett. Personal communication with author, September 2008.

Chandler, Jim. Personal communication with author, September 2008.

Graham, Otis L., Jr., and Meghan Robinson, eds. *Franklin D. Roosevelt, His Life and Times: An Encyclopedic View*. Boston: G.K. Hall & Co., 1985.

Klein, Jonas. *Beloved Island: Franklin and Eleanor and the Legacy of Campobello.* N.p.: Paul Ericsson, 2000.

Lash, Joseph P. *Eleanor Roosevelt on Campobello.* Pamphlet. N.p.: Campobello International Park Commission, 1984.

Maine Better Transportation Association. *Better Roads.* Augusta, ME: Maine Better Transportation Association, 1962.

Maine Highway News 5, no. 1 (January 1962).

Pike, Davis. Personal correspondence, 2009.

Potter, E.B. *Bull Halsey.* Annapolis, MD: Naval Institute Press, 2003.

Winship, Laurence L. "Campobello Roosevelt Bridge." *Boston Sunday Globe,* August 12, 1962.

Reburying the Father of the Coast Guard

Alderson, H. Fremont. Letter to Leighton Funeral Home, Lubec, October 22, 1974.

Bangor Daily News. "Coast Guard's Founder May Rest in Honored Place." March 31–April 1, 1973.

———. "Coast Guard to Honor First Officer in Lubec Service." May 29, 1959.

Beal, Clayton. "Hopley Yeaton remains exhumed." *Bangor Daily News,* November 2, 1974.

Black, Kenneth. Letter to Ronald Pesha, June 7, 2004.

Boyce, Peter. August 8, 2008. Interview with author.

Cullen, Sidney L. "Hopley Yeaton of North Lubec To Get Posthumous Honors." *Bangor Daily News,* December 28, 1972.

DiFrancesco, Barbara. *His Window on the World: The Piscataqua and the Days of Hopley Yeaton.* N.p.: self-published, 1997.

Fellows, Lawrence. "Hero Sails Home to the Coast Guard." *New York Times,* August 20, 1975.

Heydenreich, James G., LDCR, captain. "Hopley Yeaton." U.S. Coast Guard Academy *Alumni Association Bulletin,* September–October 1967 to November–December 1968. New London, CT: U.S. Coast Guard Academy, n.d.

Marston, Robert. December 29, 2008. Interview with author.

Morong, Shirley. "Hopley Yeaton: Father of the Coast Guard." *Lighthouse Digest* (September 2005).

Posser, Bill. "Semper Paratus." *Down East* magazine (September 1980): 87.

Lubec's 1911 Centennial

Eastport Sentinel. Unsigned editorial. May 31, 1911.

Lubec Herald, October 10, 1910, and issues from April through July 1911. Assorted news items and editorial comments, all unsigned.

Maine Register, July 1912. Grenville M. Donham, publisher, Portland, Maine.

"State of Maine Clerk's Record of Burial-Transit Permit." Photocopy of document, signed by Marylyn Curtis, town clerk, October 28, 1974.

The Fuzzy Wuzzy Cat Food House

Johnson, Ryerson, and Lois Johnson. *200 Years of Lubec History 1776–1976.* N.p.: privately published by authors, n.d.

Lubec Herald Magazine. "The Sardine Industry" (December 1899).

————. "The Voyage of the Quoddy Belle" (December 1899).

The Town and Village of Lubec: A Hundred Years of History Briefly Told. Lubec, ME: Lubec Herald, 1899.

A Colorful Bunch

Bangor Daily News. Unsigned story regarding Sumner Pike on the Atomic Energy Commission. February 15, 1950.

Bohlen, Nina. Correspondence with author, 2009.

Harding, Diana Pike. Correspondence with author, 2008–9.

Lemon, Penelope Pike. Correspondence with author, 2008–9.

Little, George Thomas, and Henry Sweetser Burrage. *Genealogical and Family History of the State of Maine.* N.p.: Albert Roscoe Stubbs, 1909.

Lubec Herald, July 16, 1952.

McCurdy, John. Telephone conversation with author, 2009.

New York Times. February 23, 1976. Sumner Pike obituary.

Pike, Davis. Conversation and correspondence with author, 2008–9.

Pike, Jacob. Correspondence with author, 2009.

Pike, Ronald, comp. *Pike Family Genealogy.* Undated handwritten copy located in Lubec Historical Society files that states that a copy is also located in the Mormon Library, Salt Lake City.

Pike, Sumner, as told to Sidney Shalett. "Grandpa Was a Smuggler." *Saturday Evening Post,* August 28, 1948.

Pike, Sumner. Tape-recorded newspaper interviews, 1974 and 1975, from the collection of Davis Pike.

Portland Press Herald. Unsigned story regarding the Atomic Energy

Commission. June 7, 1950.

Rugh, Anne Pike. Conversation and correspondence with author, 2009.

Time. "Sumner Pike." July 10, 1950.

Varney, George J., ed. *State of Maine 1881.*

Death of a High School

Baker, Victoria. *Quoddy Light.* Lubec High School yearbook, June 1936.

Bangor Daily News, March 26, 1975.

Doherty, Miriam Kelley. Interview with the author. October 2008.

Farmer, Shelley. Interview with the author. January 14, 2009.

Keene, Julie. Interview with the author. November 2008.

Lubec Herald. Account of school fire. December 2, 1913.

———. Issues from 1910 and 1937.

———. "Lubec, Then and Now, Schools." March 18, 1937.

McGonigal, John. Interview with the author. November 2008.

Morong, Shirley. "Old High School Was Tough to Tear Down." *Quoddy Tides*, September 27, 2002.

Quoddy Light 1, no. 1 (June 1916): 9.

Quoddy Light (June 1949).

Sturtevant, William. *Annual Report of the Municipal Officers of the Town of Lubec for the year ending March 23, 1914.*

The Sardine Workers

Coggswell, John F. "Three Billion Little Fishes!" *Saturday Evening Post*, January 16, 1943.

Gilman, John. *Canned: A History of the Sardine Industry.* Lambertville, New Brunswick: self-published, 2001.

Herring. Gulf of Maine Research Institute. http://www.gma.org/herring/default.asp.

McCurdy, Suzanne. "A Short History of the Sardine Business in Lubec." *200 Years of Lubec History 1776–1976.*

Moores, Shirley. March 2009. Interview with author.

O'Leary, Wayne M. *Maine Sea Fisheries: The Rise and Fall of a Native Industry 1830–1890.* Boston: Northeastern University Press, 1996.

Rahilly, Jerry and Rita. May 2009. Interview with author.

Wood, Pamela. "Inside a Sardine Factory." *Salt* 6, no. 2 (December 1983).

———. "Moses Pike Running the Holmes Packing Plant." *Salt* 6, no. 1 (December 1983).

The Naming of Lubec

"Aboriginal Place Names." Indian and Northern Affairs Canada. http://www.ainc-inac.gc.ca/pr/info/info106_e.html, accessed December 11, 2008.

Adams, Frank P., Sr. "How Lubec Was Named." Clipping from unnamed newspaper in Lubec Historical Society collection.

Bright, William. *Native American Place Names of the United States.* Norman: University of Oklahoma Press, 1994.

BIBLIOGRAPHY

Chadbourne, Ava Harriet. "Maine Place Names and the Peopling of Its Towns." *Cumberland Press*, Washington County edition, 1971.

Commonwealth of Massachusetts. "Lubeck Charter." June 19, 1811, photographic reproduction. This reproduced document is on permanent display at the Lubec Historical Society.

Eckstorm, Fannie Hardy. *Indian Place-Names of the Penobscot Valley and Maine Coast*. Orono: University of Maine Press, 1978.

Gallagher, John, with Nicole Fourmond Moores. "Should it Be Lubec—or Lebec?" circa 1988. From unnamed newspaper clipping located in the Lubec Historical Society Collection.

Huden, James C. *Indian Place Names of New England*. New York: Museum of the American Indian, 1962.

Kilby, William Henry. *Eastport and Passamaquoddy*. Eastport, ME: Edward E. Shead & Company, 1888.

LeSourd, Phillip S. *Passamaquoddy-Meliseet and English Dictionary*. Edited and revised by Robert M. Leavitt, et al. Passamaquoddy-Maliseet Bilingual Program ESEA Title VII. Perry, ME: n.d.

"Lübeck." Wikipedia, the free encyclopedia. http://en.wikipedia.org/wiki/Lubeck.

Lubec, Maine Town Documents, 1817. Located at Lubec Town Hall.

Maine: Federal Writers' Project. Boston: Houghton Mifflin Company, 1937.

McGregor, James. *History of Washington Lodge No. 37 1822–1890*. Portland, ME: E.W. Brown & James B. Neagle, 1892.

Pike, Ronald, and George J. Varney, eds. *State of Maine 1881*.

Ross, Bernard. "History Can Be Very Interesting." *Lubec Historical Society Newsletter*. Lubec, ME: Lubec Historical Society, 2005.

BIBLIOGRAPHY

Schad, Vicki J. Reynolds. *Some Early History of Lubec, Maine.* Lubec, ME: self-published, 2001.

Townsend, Patricia McCurdy. *Vital Records of Lubec, Maine, Prior to 1892.* Camden, ME: Picton Press, 1996.

Weaver, Eloise. Parkersburg and Wood County Public Library Geneaology Department. E-mail corresponce, October 17, 2008.

Visit us at
www.historypress.net